Man and Machine

man and machine

Photographs by

Henri Cartier-Bresson

A Studio Book · VIKING PRESS · NEW YORK

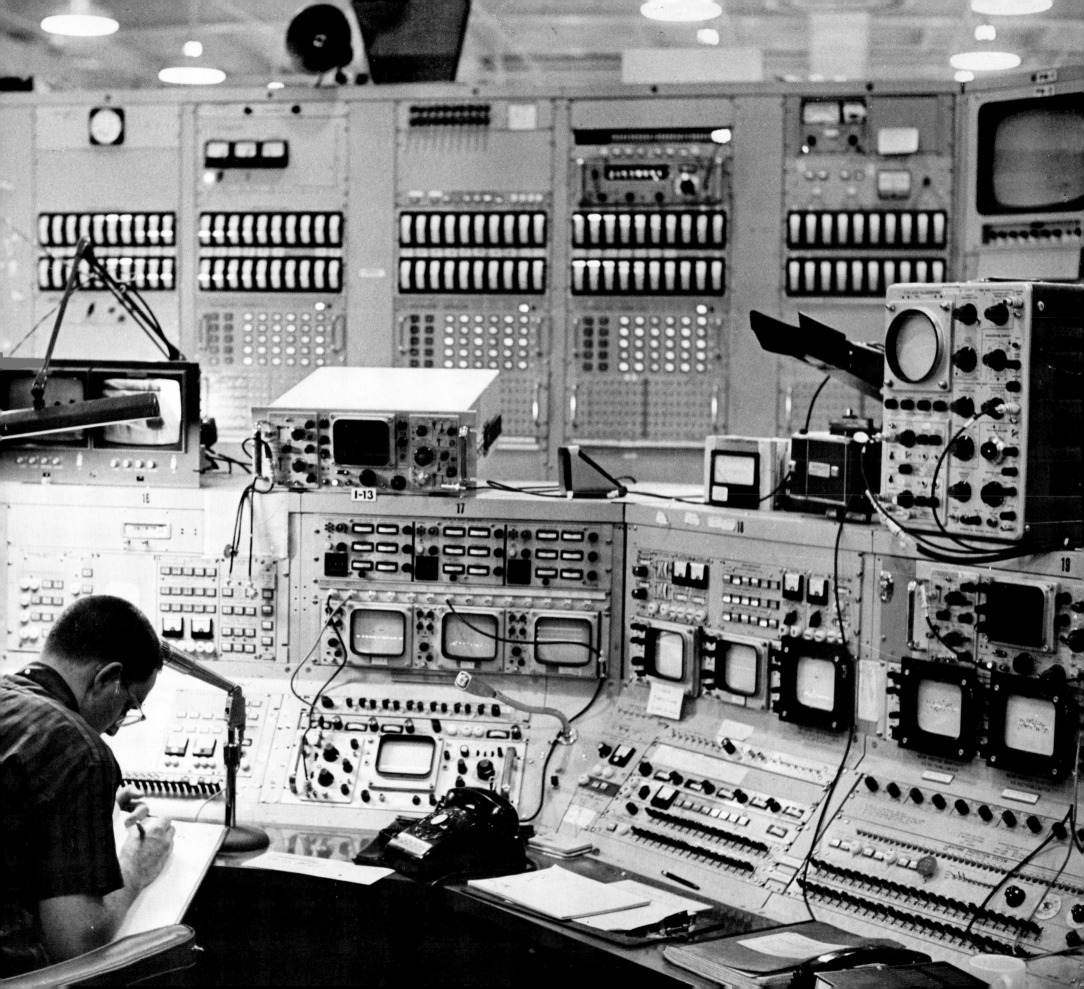

Foreword

This series of photographs is in its quiet way a partial portrait of mankind—in our close and often subconscious dialogue with technological change. It is a personalized mirror of our times, and of an especially significant new relationship: not that of man to nature, or of man to man—the traditional links between the individual and his environment—but that of man to machine. This new relationship appears most dramatically neither in the formal struggle between the engineer and his electronic or mechanical world, nor in the conscious association of the worker with his tools, but rather in the incidental occurrences of everyday life.

With man, as with matter, chance and randomness may actually be the most representative forms of reality. The accident of human expression, the passing look of curiosity, of boredom, discovery, frustration, enthusiasm, faith or happiness—such unique moments can be caught by that modern instrument, the camera, but only when it is mastered by an artist who has overcome its physical limitations and freed himself from its material constraints.

This indeed is the theme of the book: the mastery by man of his own electronic and mechanical creations. By his personal example of human control over a technical tool, through photographs which capture fleeting truths, and through his profound artistry, Henri Cartier-Bresson reveals to us the interdependence of subject and object.

Throughout the early industrial age, Western man was quite often forced to adapt himself, even in a sense to subject himself, to the machine. To this day we have not yet completely reversed the relationship, for there is still much to be understood and much to be done in mastering our technological innovations. But if we train new generations of men, not only in new machines and system skills, but in continuing human awareness of them, we can expect extraordinary and beneficial changes in our world. They will occur increasingly and more widely during this century, if we plan with sensitivity and learn to harness our inventions and innovations for the total good. Mankind in the process will have mastered much more than our machines alone. We shall all have gained a new intellectual and esthetic understanding of our dynamic, changing environment.

In this, we are aided by Henri Cartier-Bresson, through his authentic vision of truth and beauty as seen through the lens of his optical machine. Looking into the complex problems of man's relationship with all machines, we find in these photographs a path leading from physical reality to a better human appreciation of its significance to us. Images so inspired, filtered through the art of one of today's greatest photographers, give us deeper insight into the real meaning of both modern humanism and modern technology.

This collection of
photographs by Henri
Cartier-Bresson on
man's continuing
dialogue with machines
was commissioned by
the IBM World Trade
Corporation, New York.
The book has been
produced with the assistance
of Bruce MacKenzie and
Robert Delpire for text
and design.

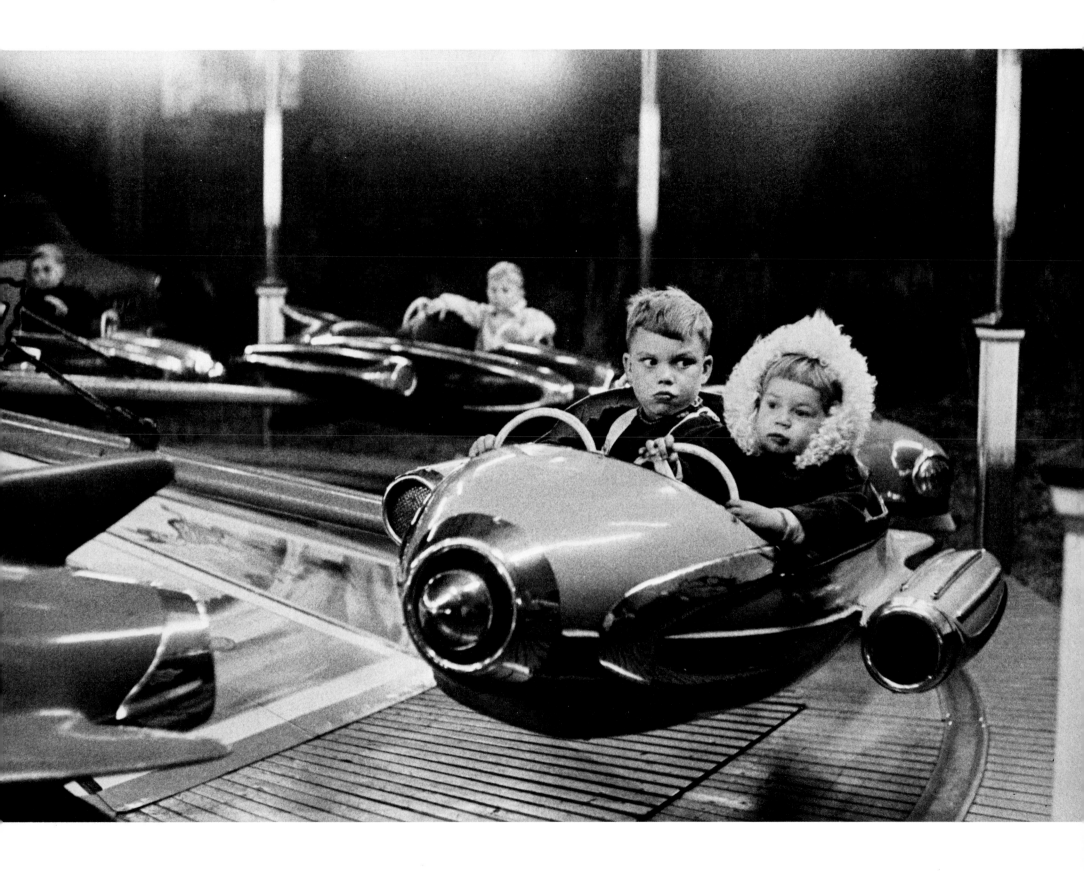

Wonders are many, and none
is more wonderful than man.

Sophocles

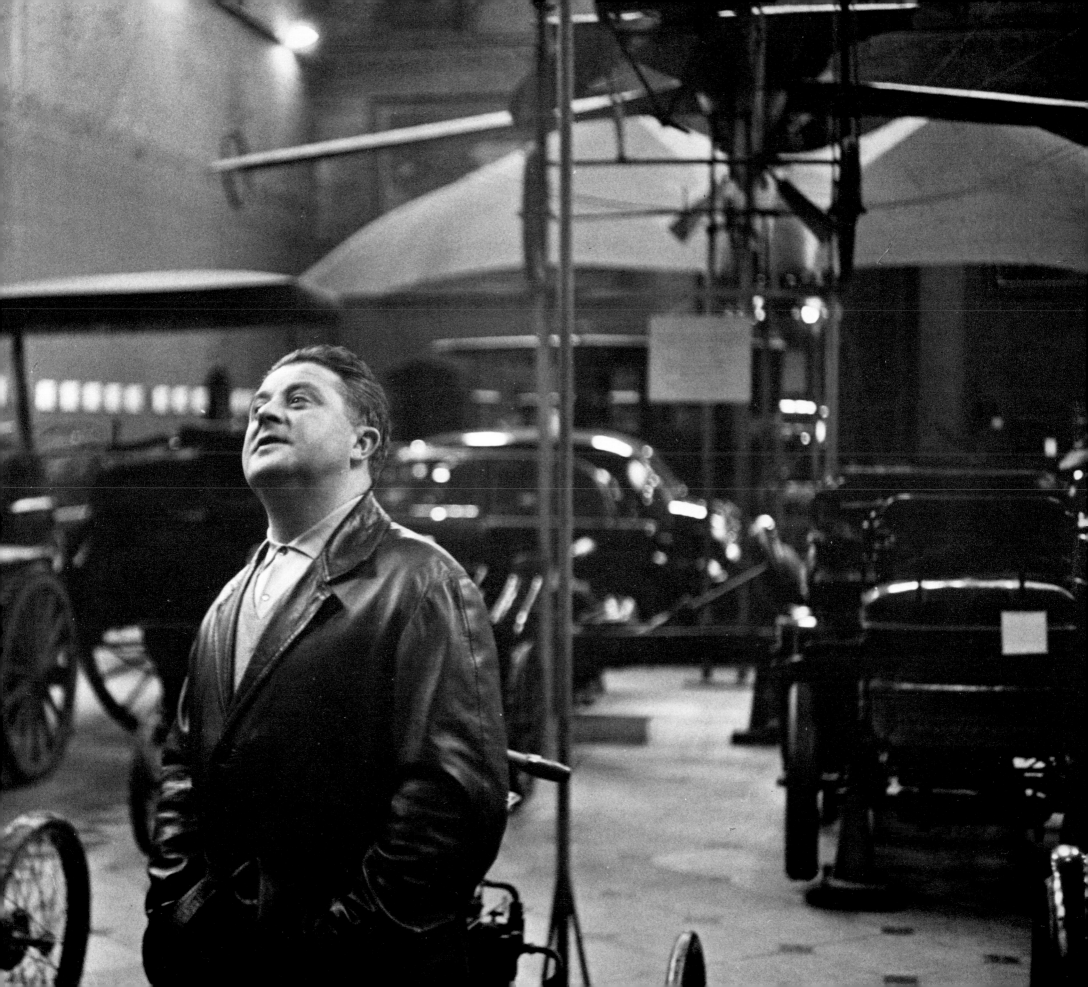

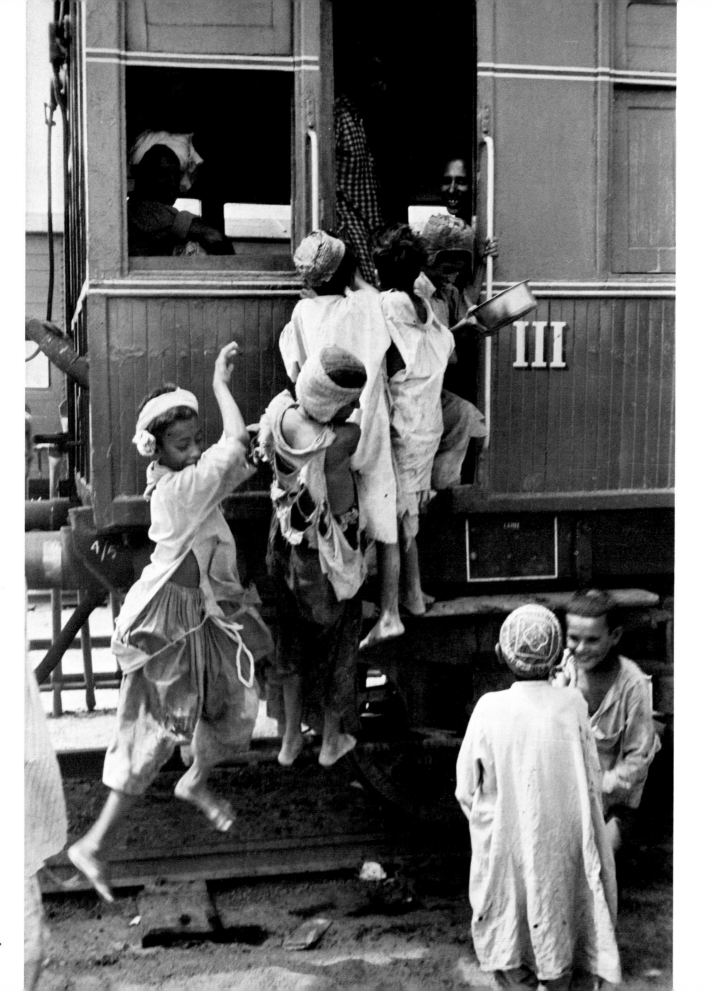

Thinking makes it so.

Shakespeare

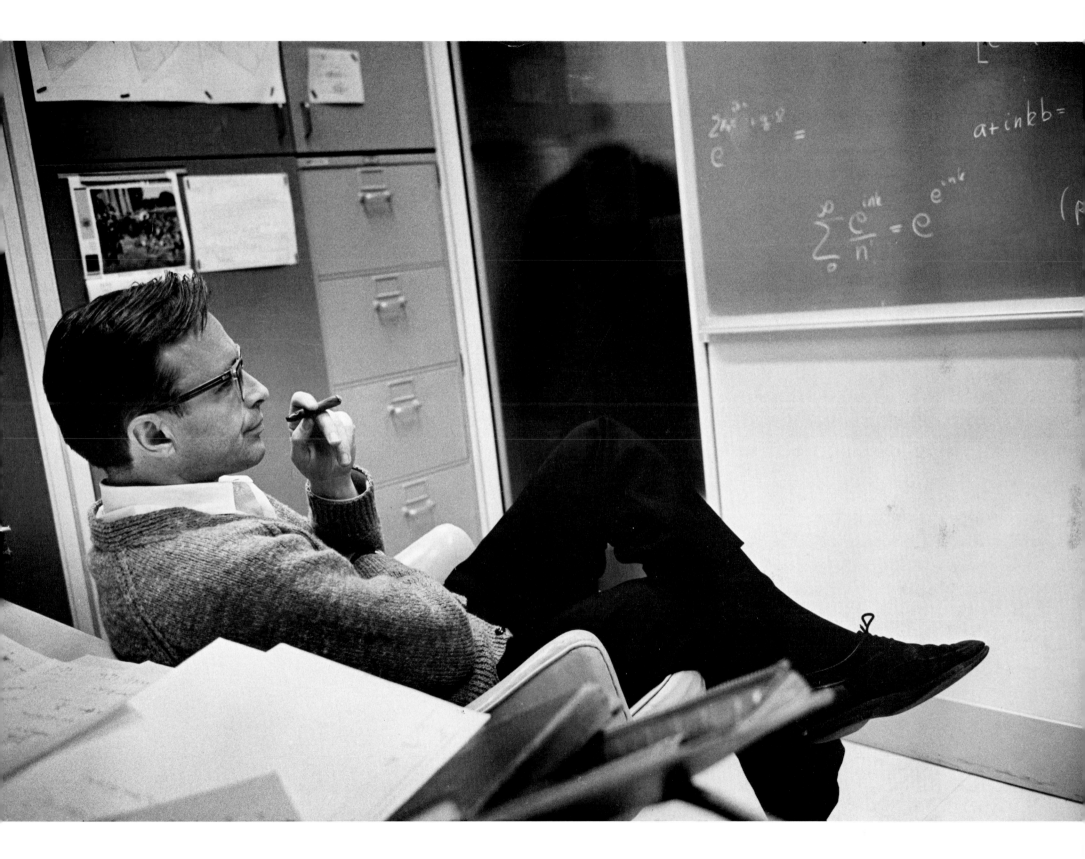

15

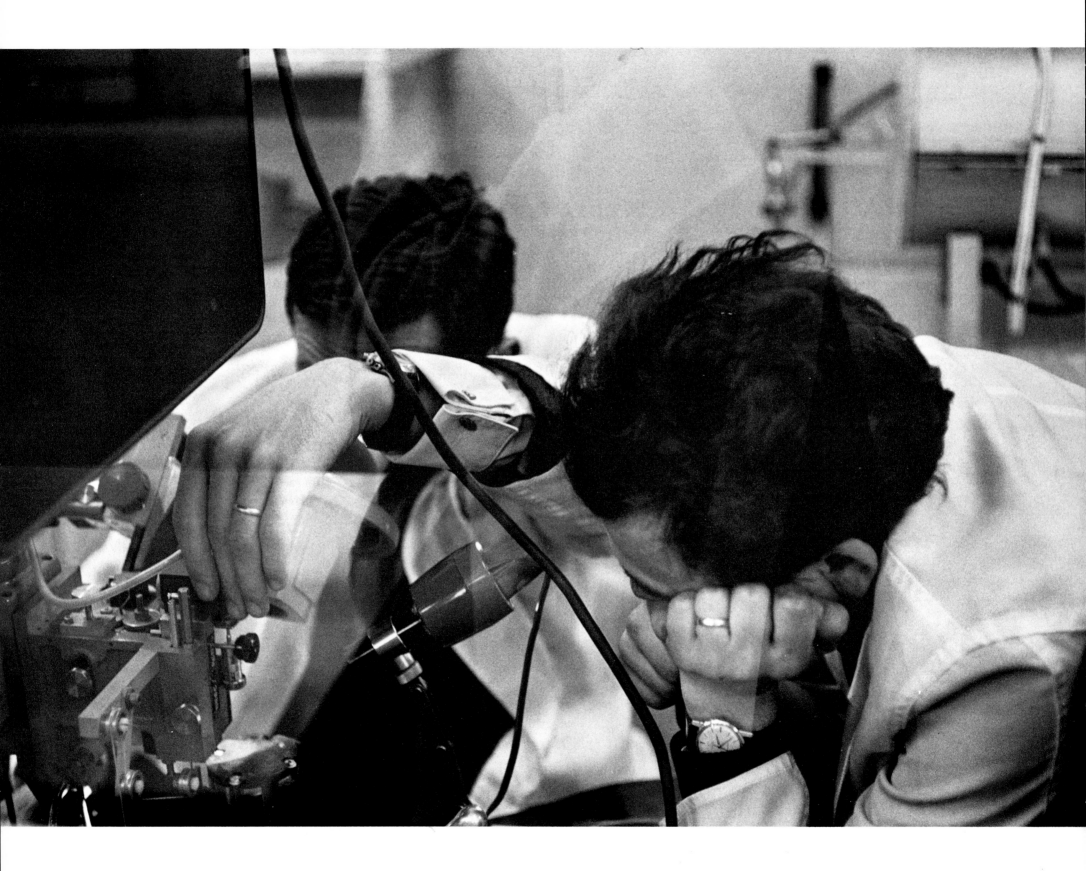

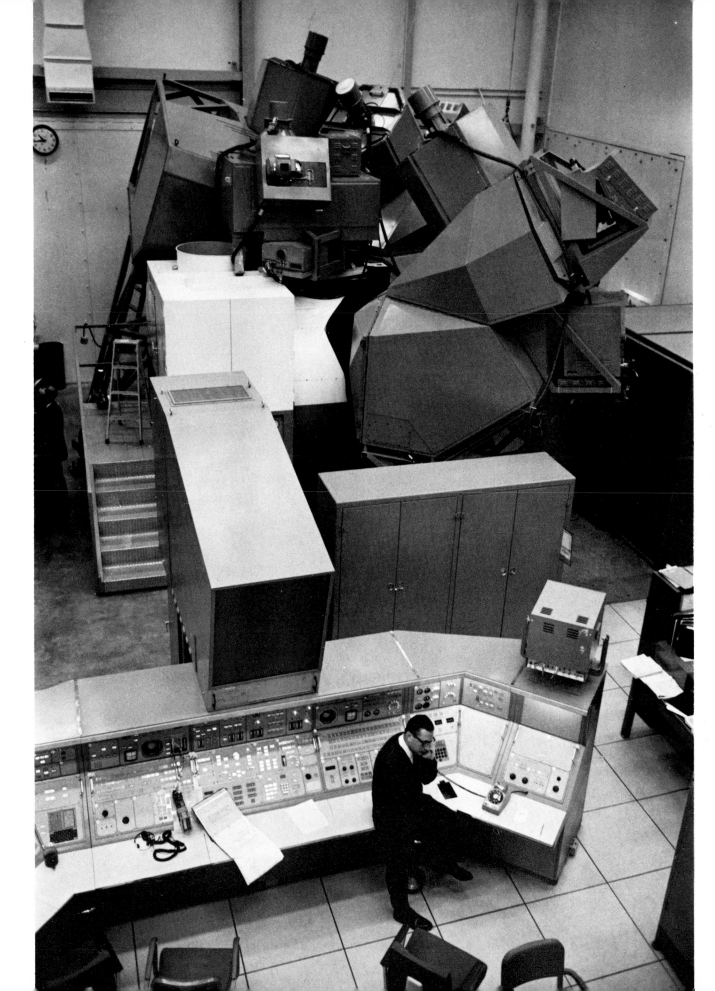

One machine can do the
work of fifty ordinary men.
No machine can do the work
of one extraordinary man.

Elbert Hubbard

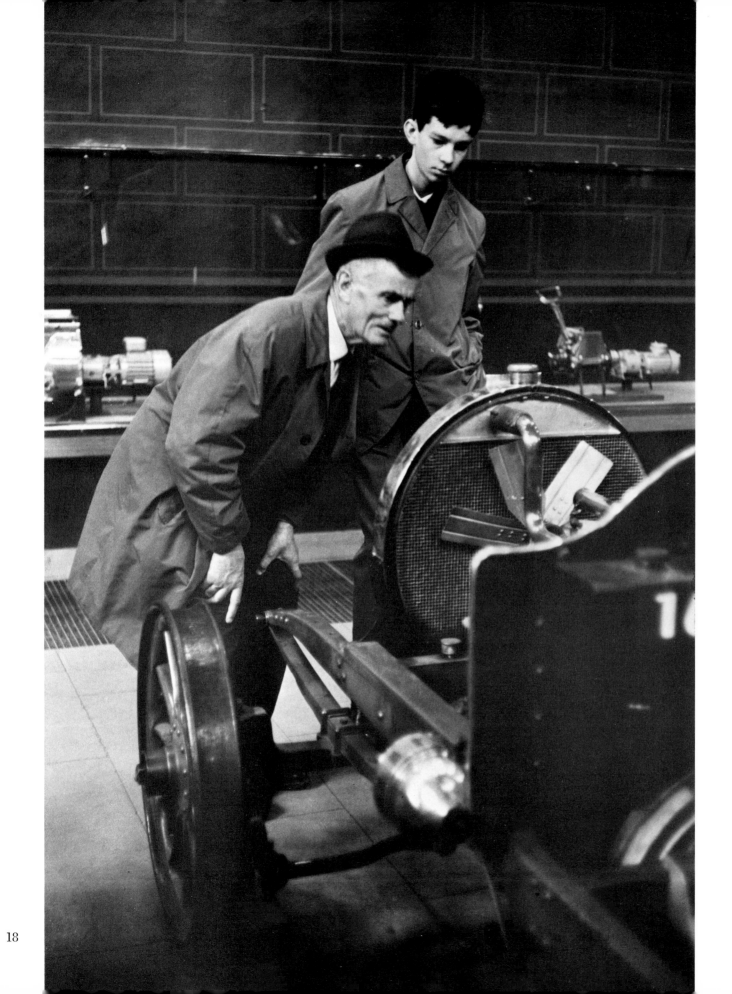

We have the aspirations
of creators and the propensities
of quadrupeds.

W. Winwood Read

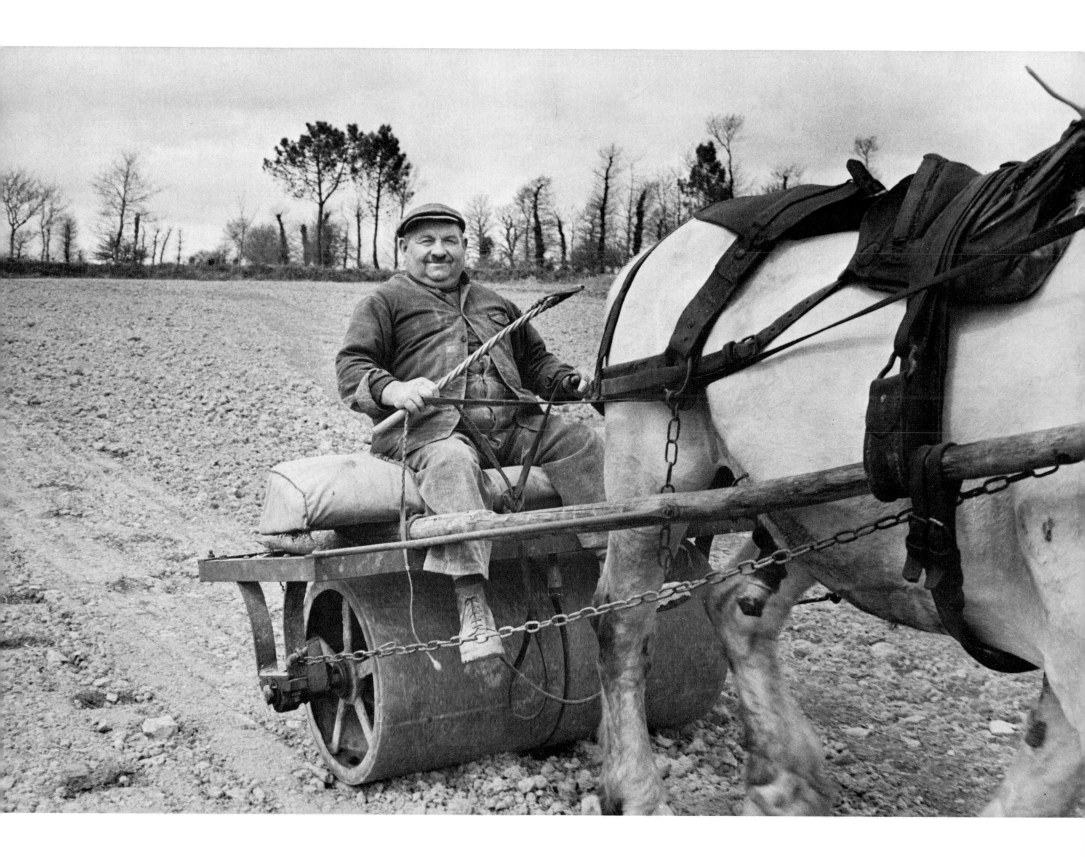

19

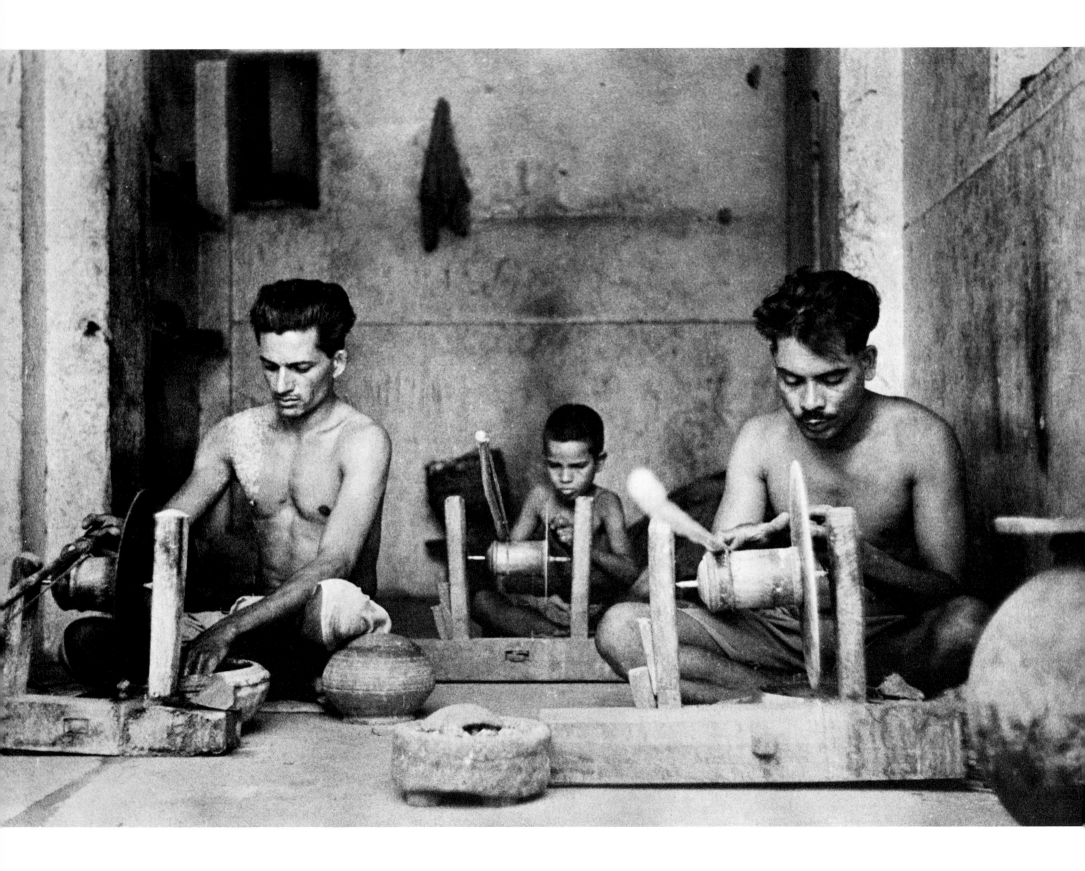

Man is a tool-using animal.
Nowhere do you find him
without tools;
without tools he is nothing,
with tools he is all.

Thomas Carlyle

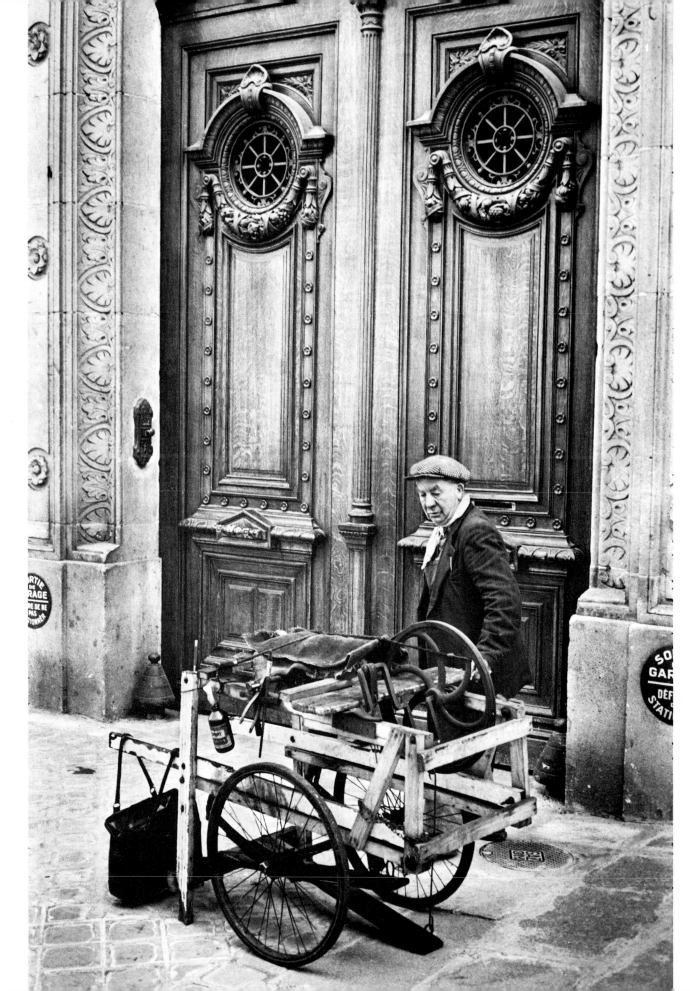

21

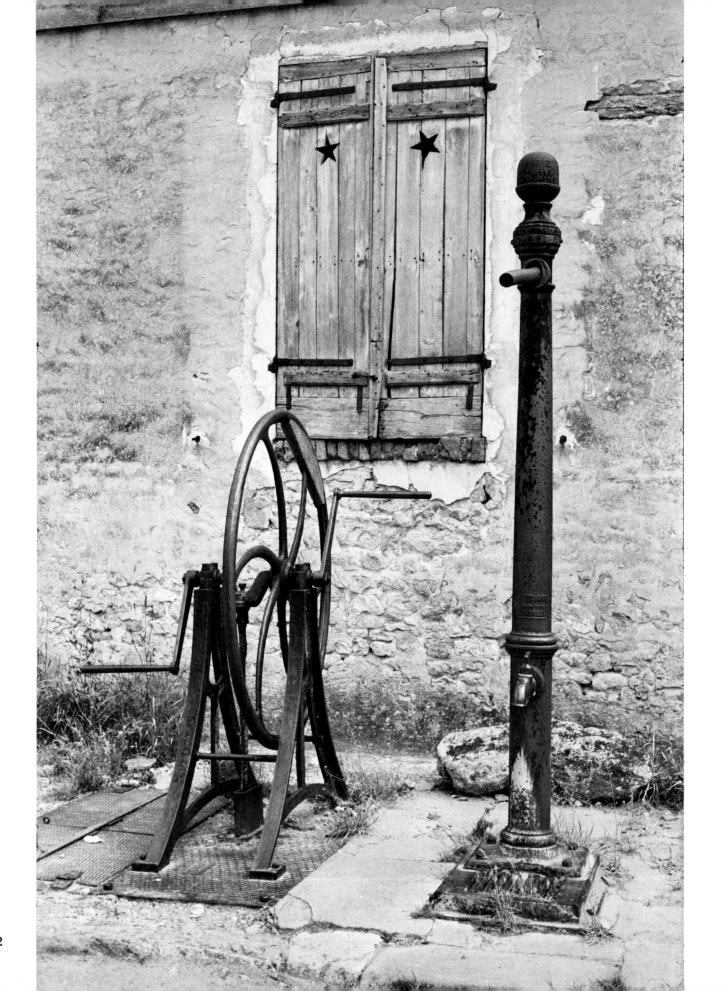

Necessity is the mother of invention.

Plato

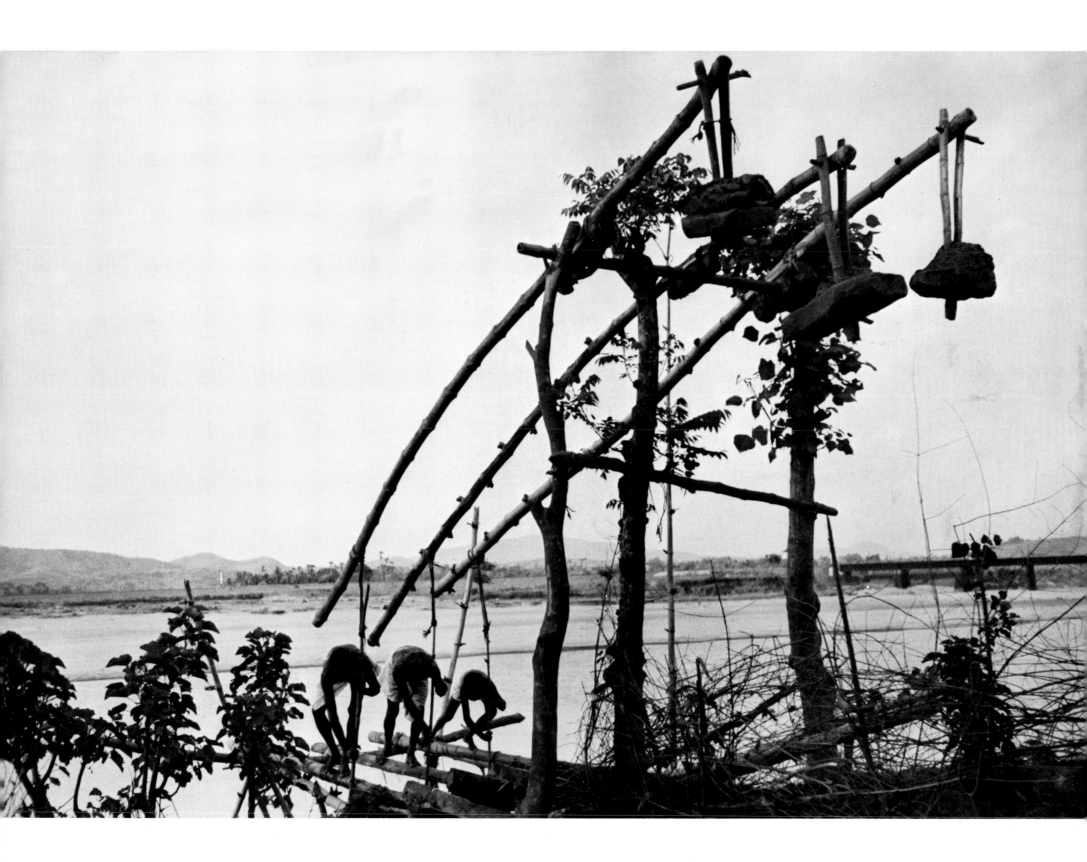

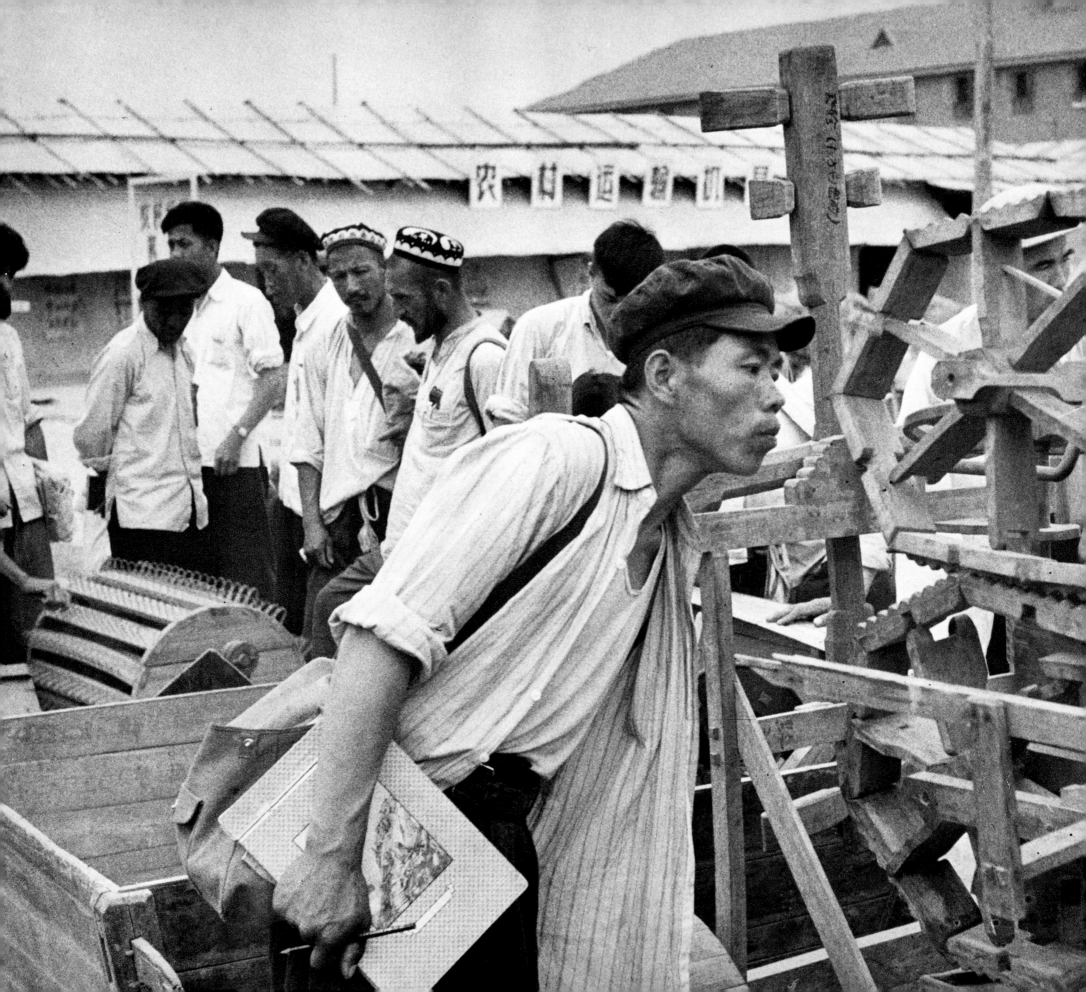

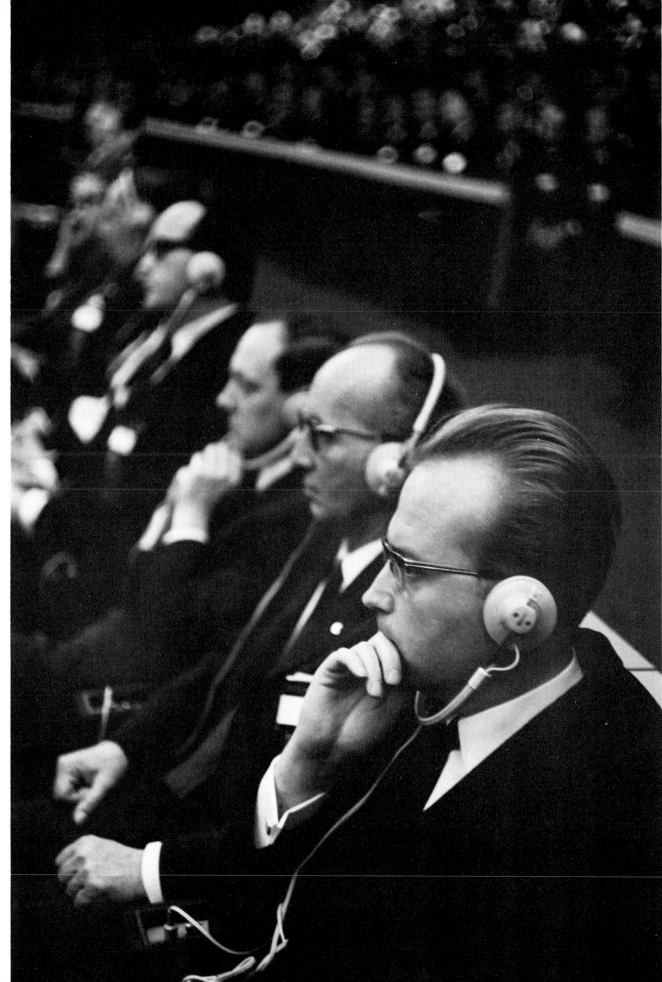

Whatever moves
is moved by another.

St. Thomas Aquinas

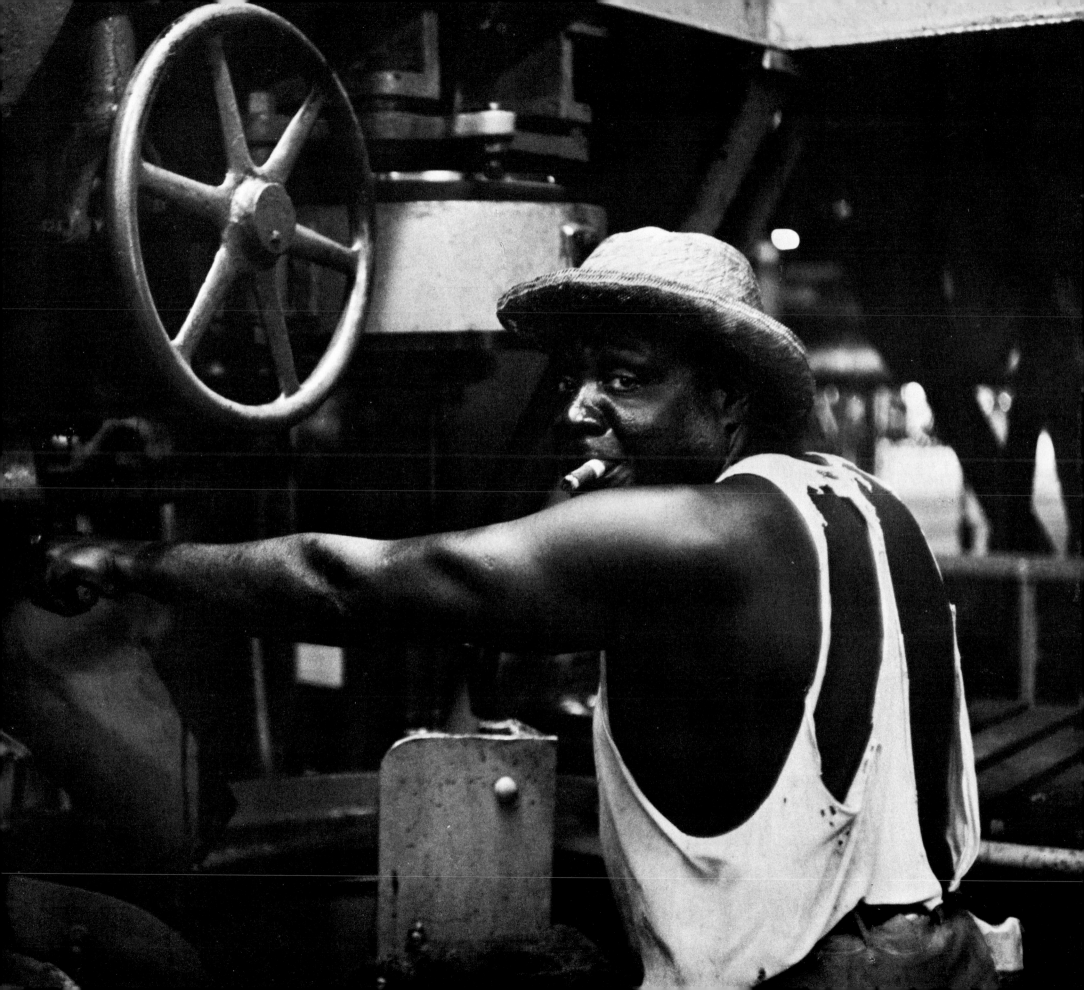

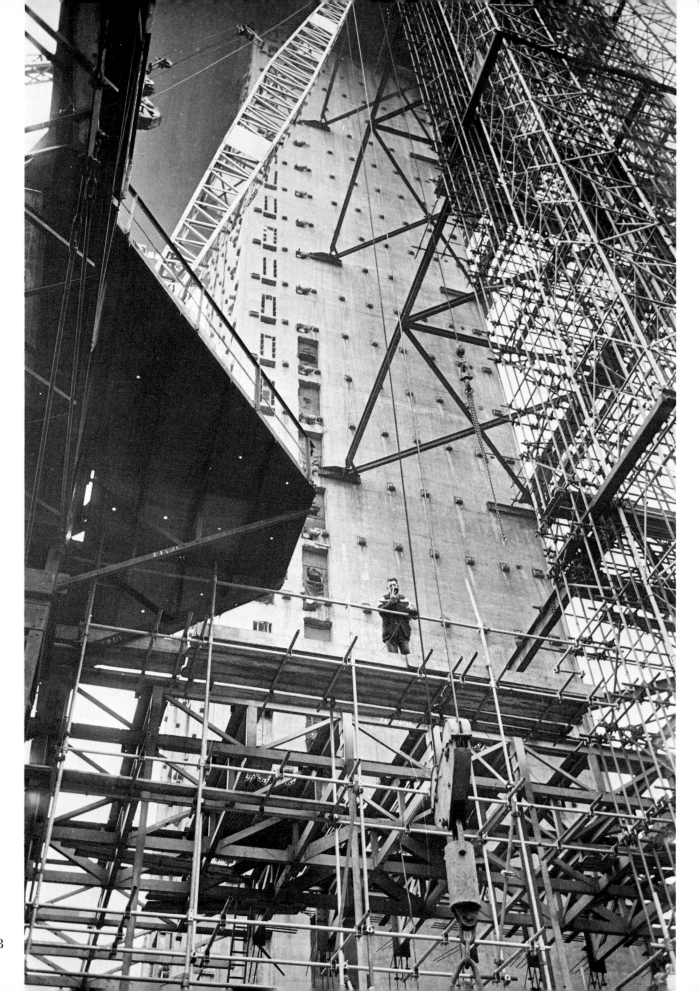

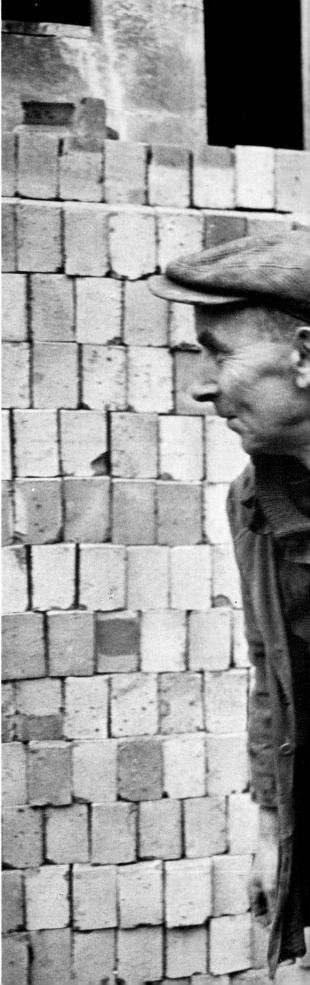

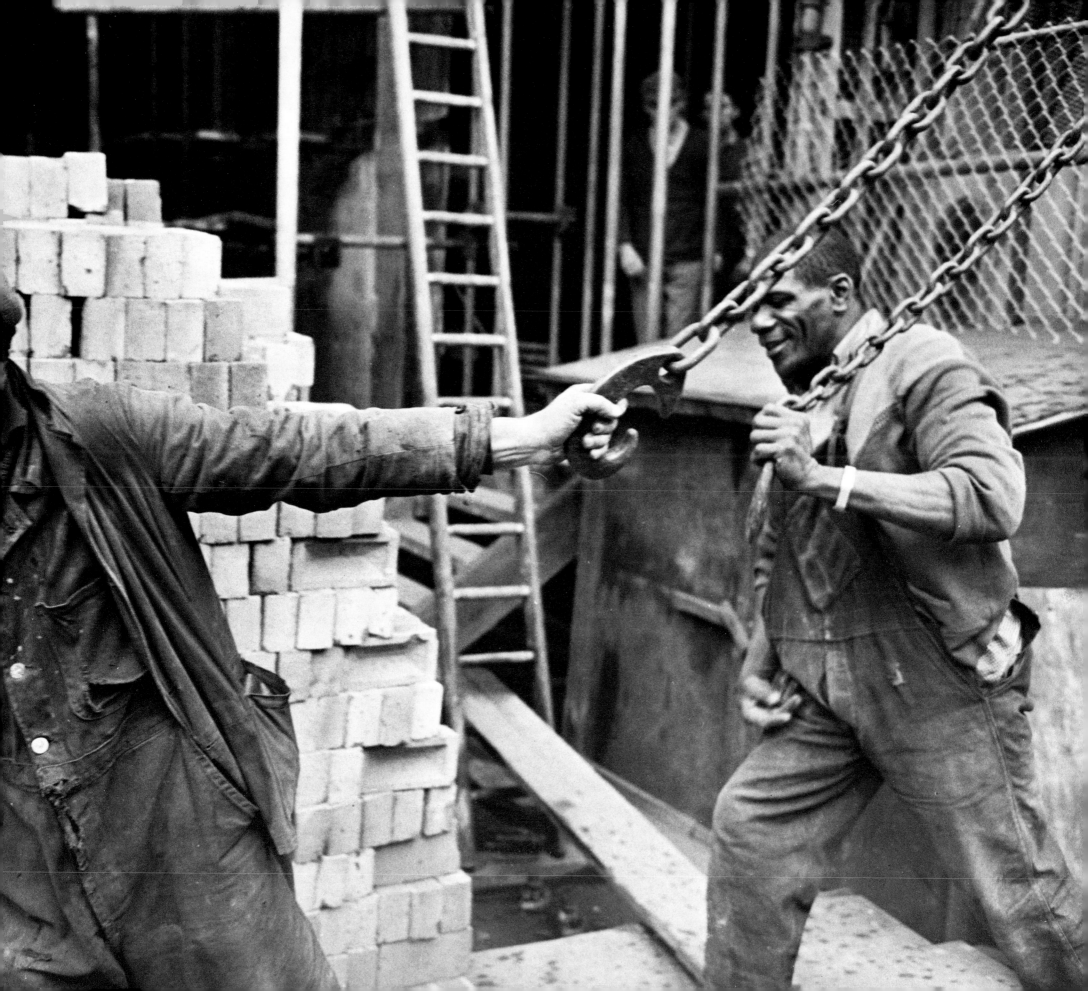

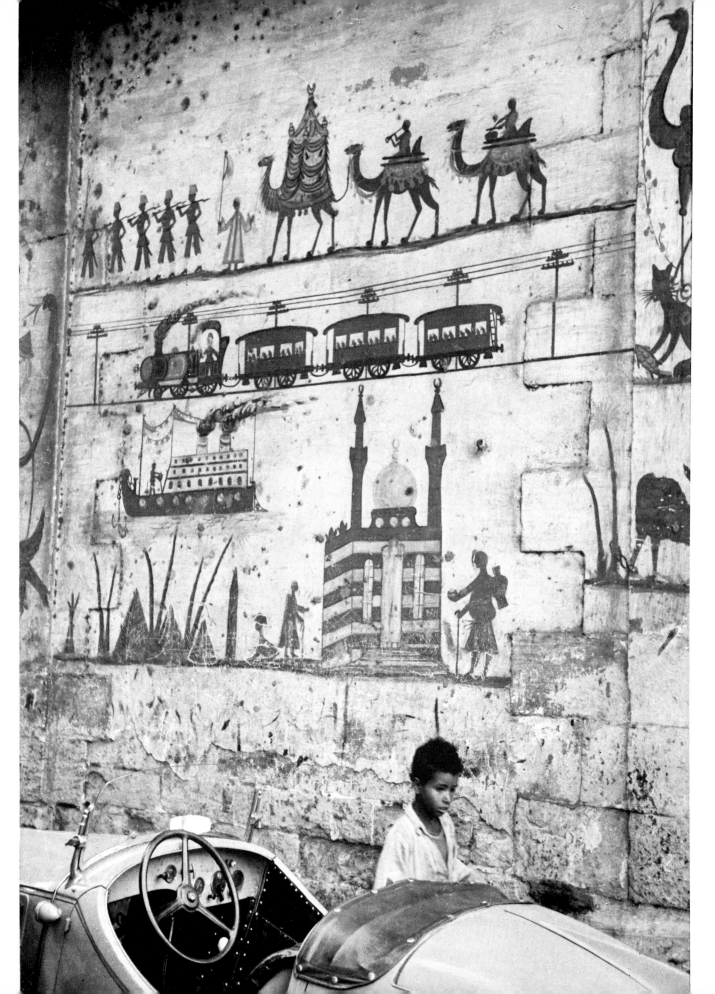

What are a hundred years
of the Machine Age compared
to the two hundred thousand years
of the history of man?

Antoine de Saint-Exupéry

A convenient way
to explain the machine
is to compare it
with man himself.

Gilbert Burck

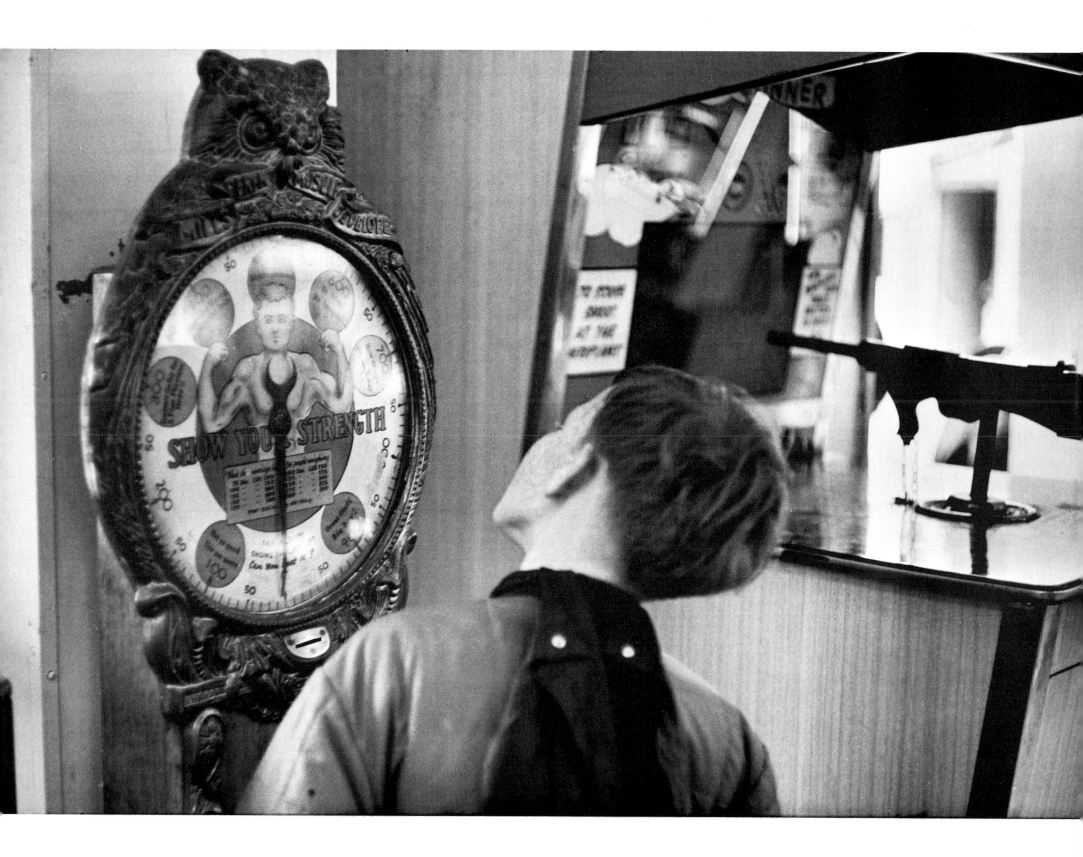

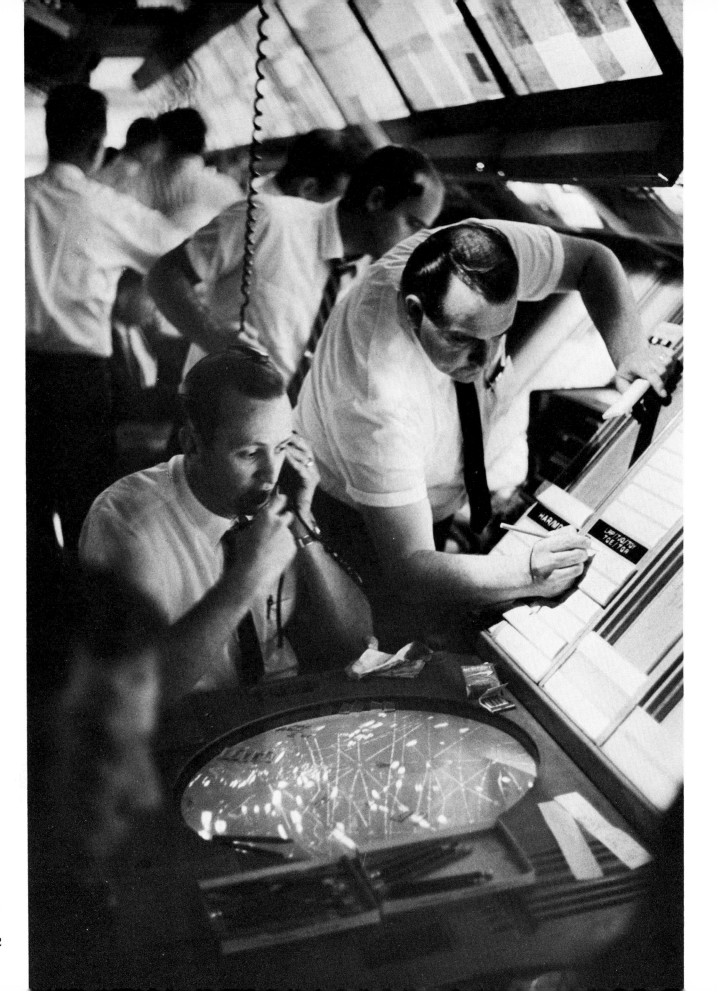

This is a Man Age.
The machines are simply tools
which man has devised
to help him do a better job.

Thomas J. Watson

Discovering the beauty
of technical objects
is not a matter of
esthetic perception alone;
the function of the object
must be understood and become
part of the thought. This
requires technical education.

Gilbert Simondon

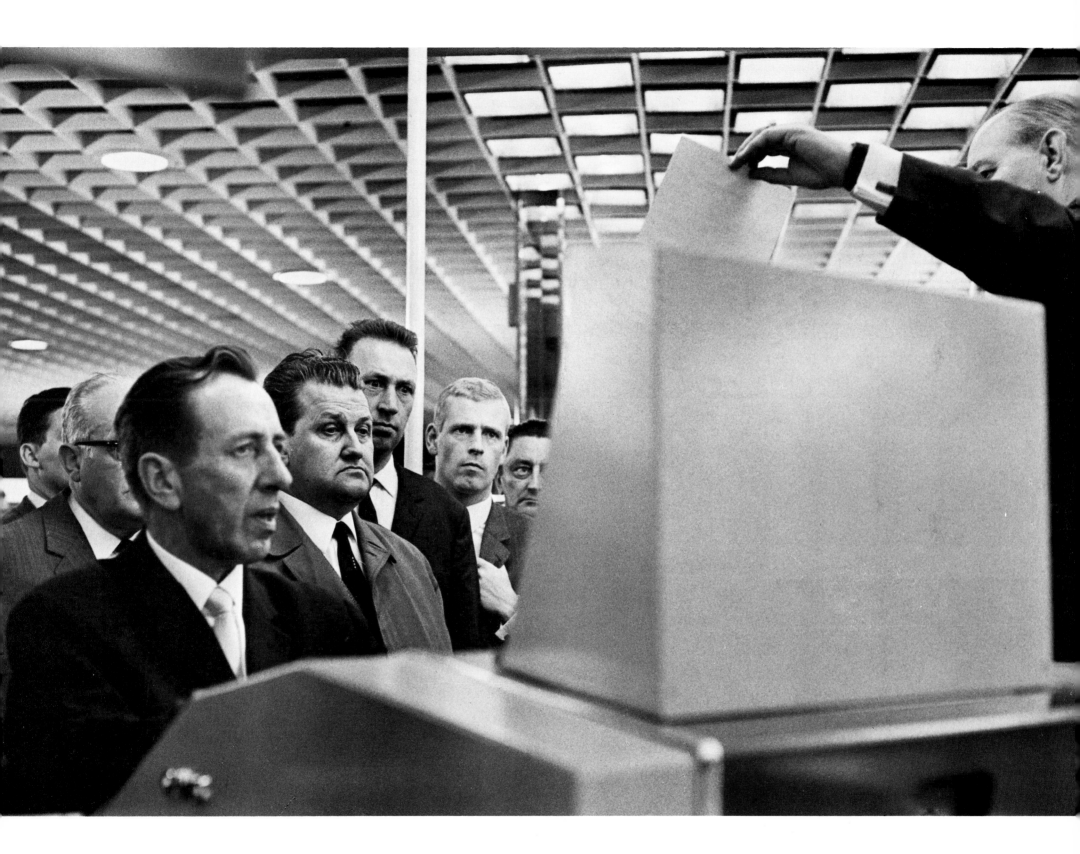

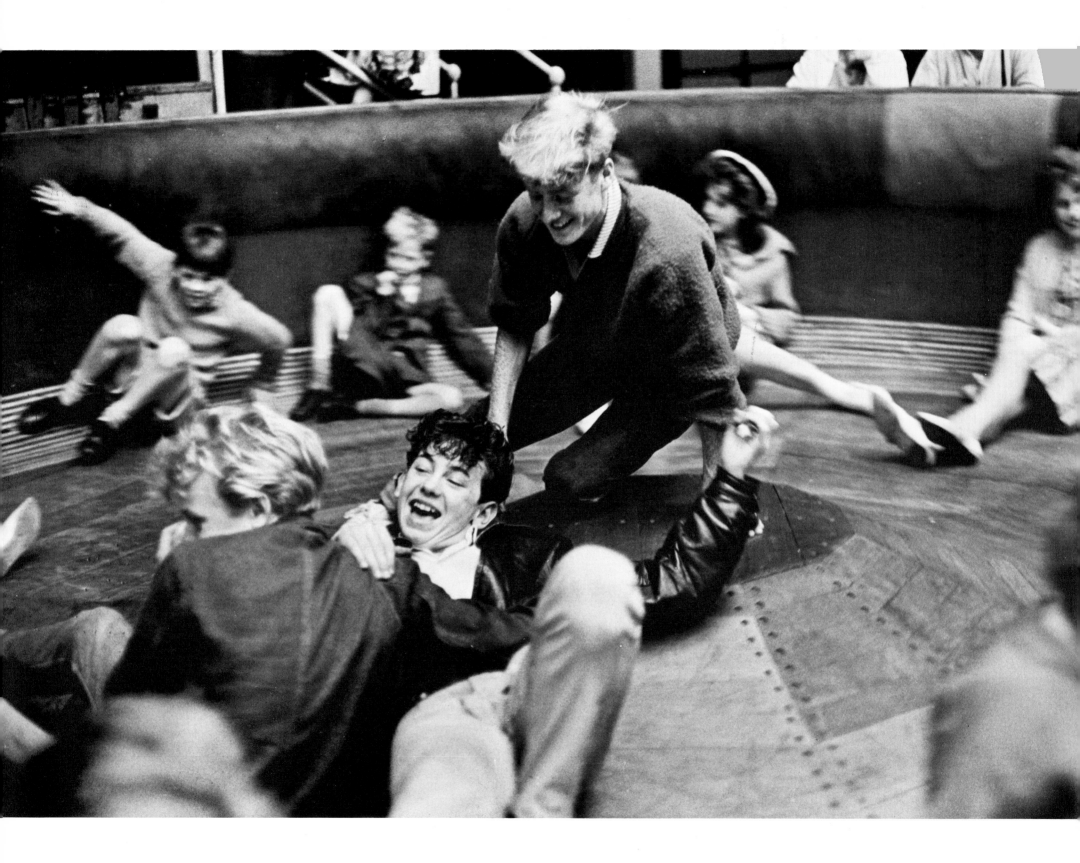

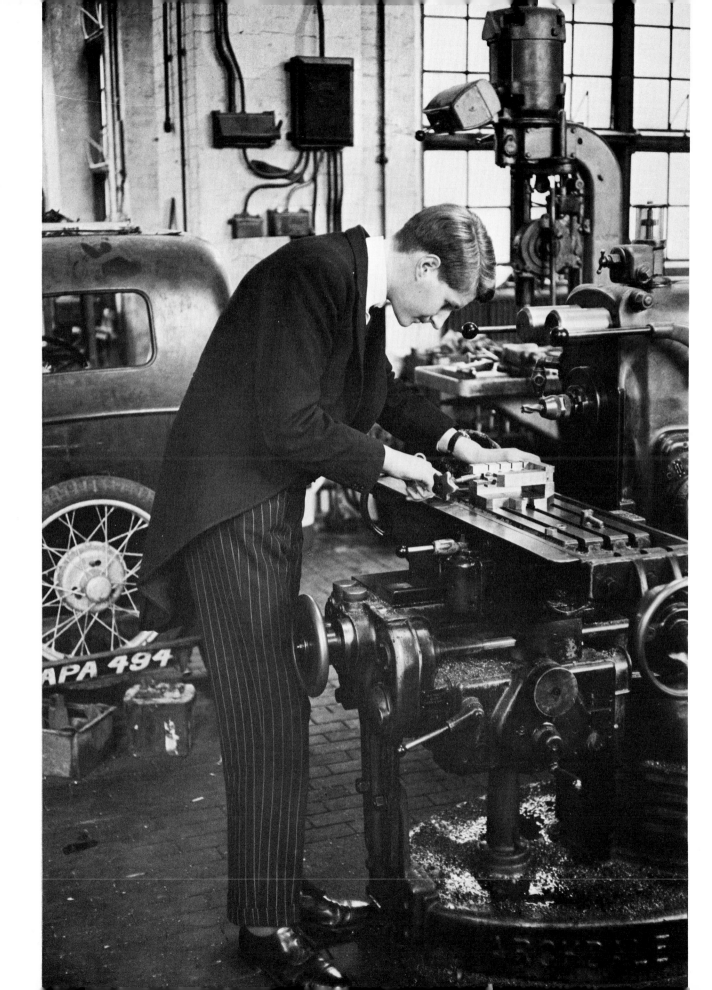

We are all very young
barbarians fascinated still
by our new toys.

Antoine de Saint-Exupéry

35

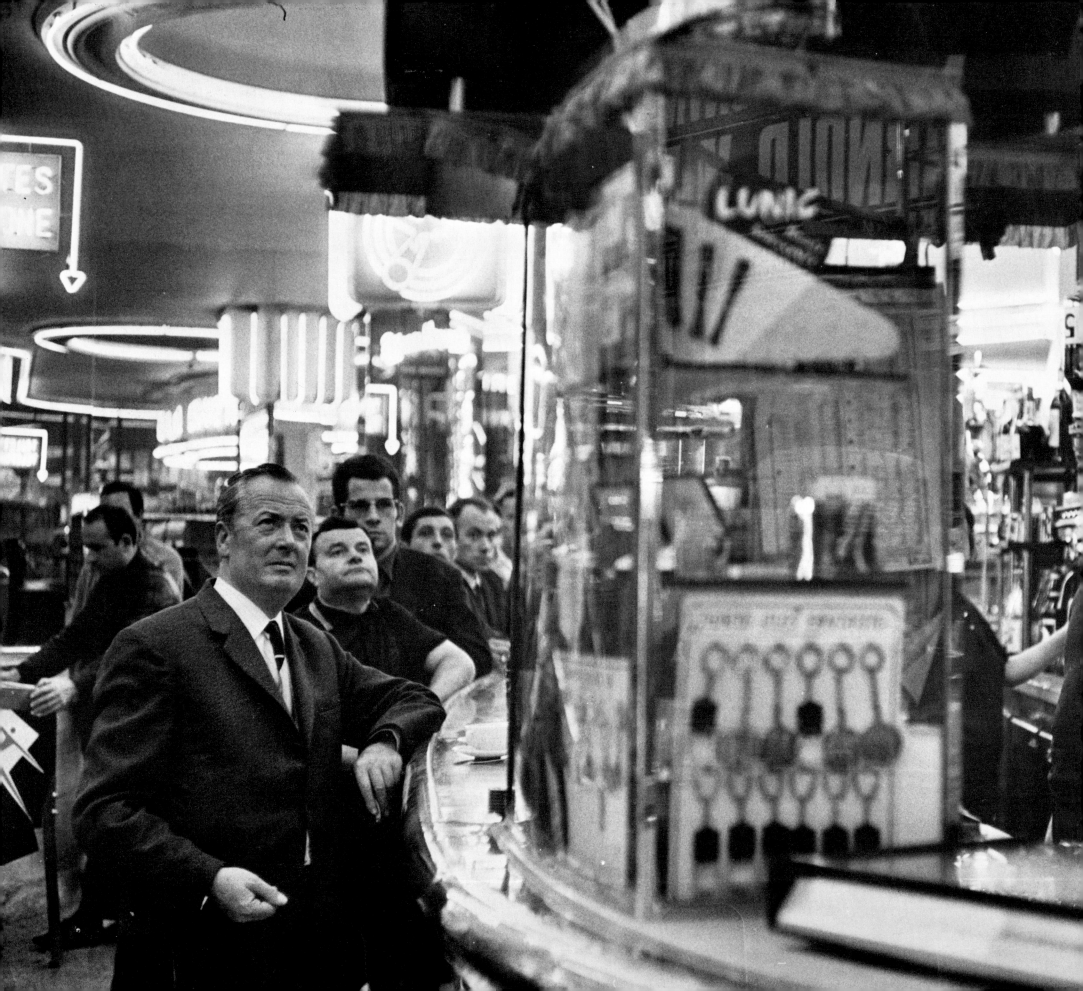

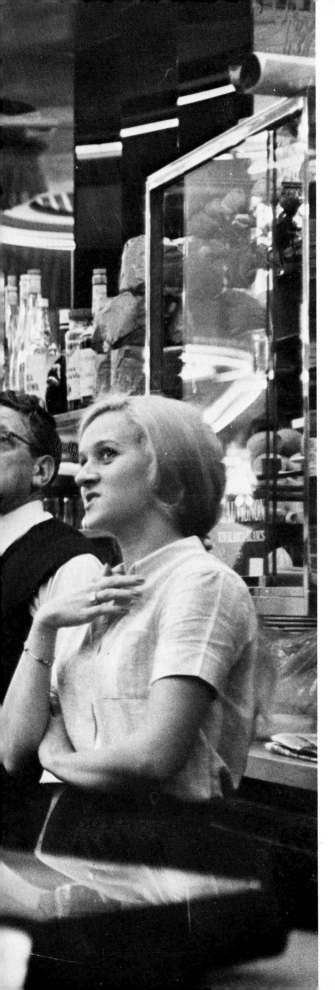
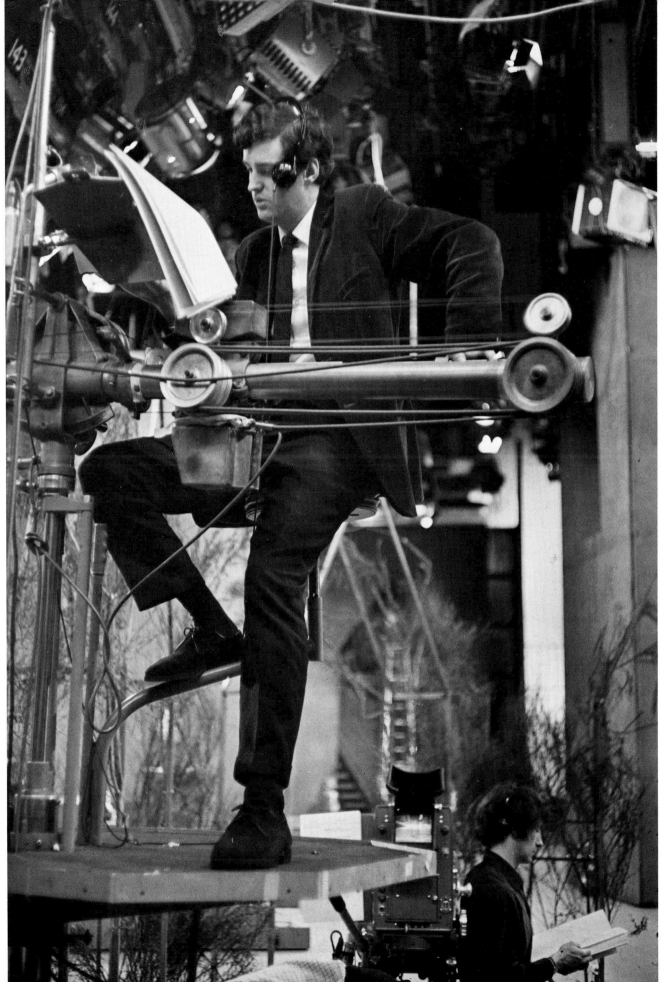

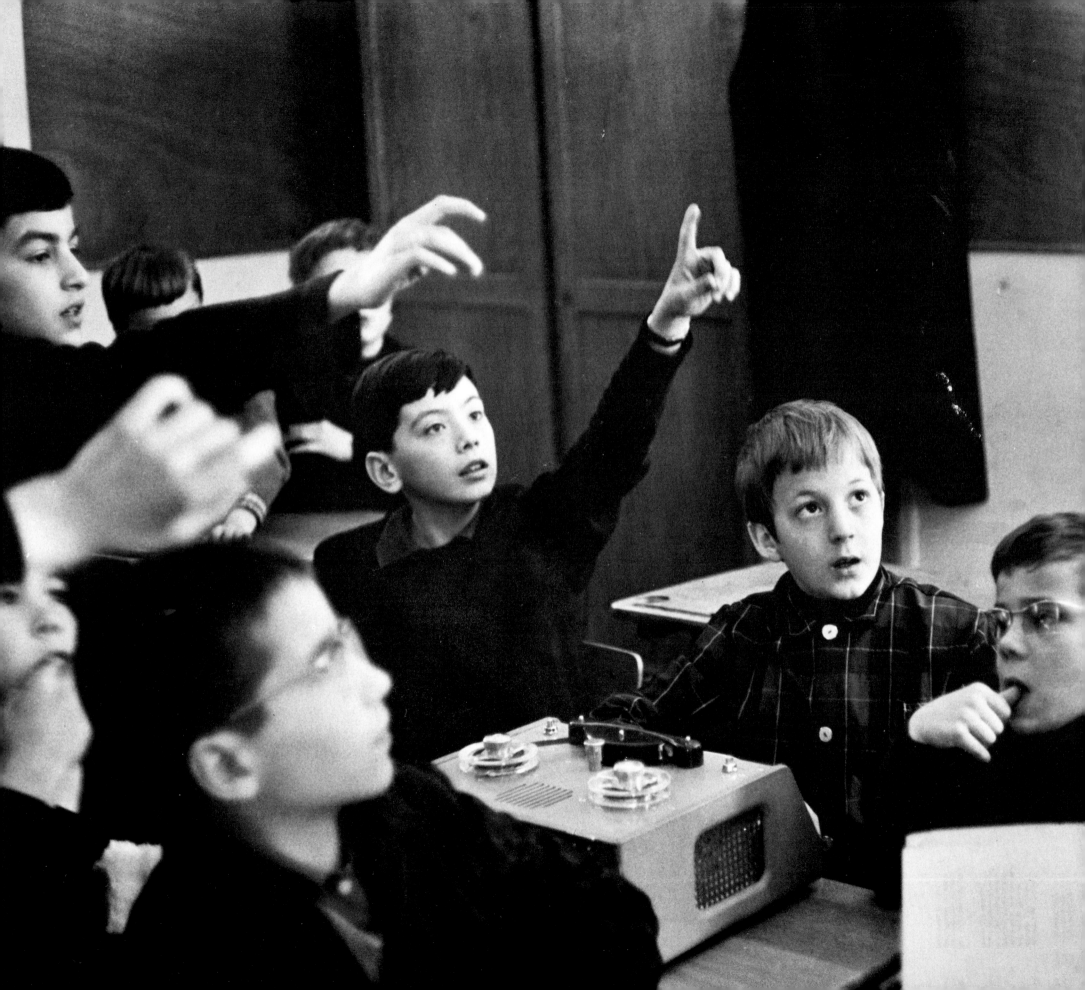

We have not become
aware of the possibility of
arranging the entire human
environment as a work
of art, as a teaching machine
designed to maximize
perception and to
make everyday learning
a process of discovery.

Marshall McLuhan

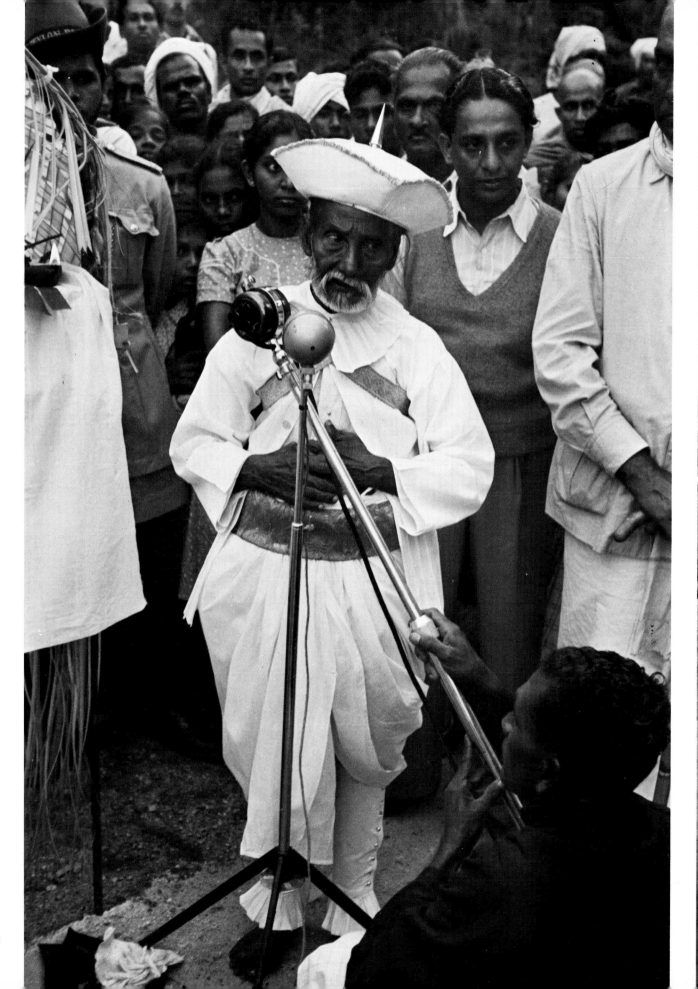

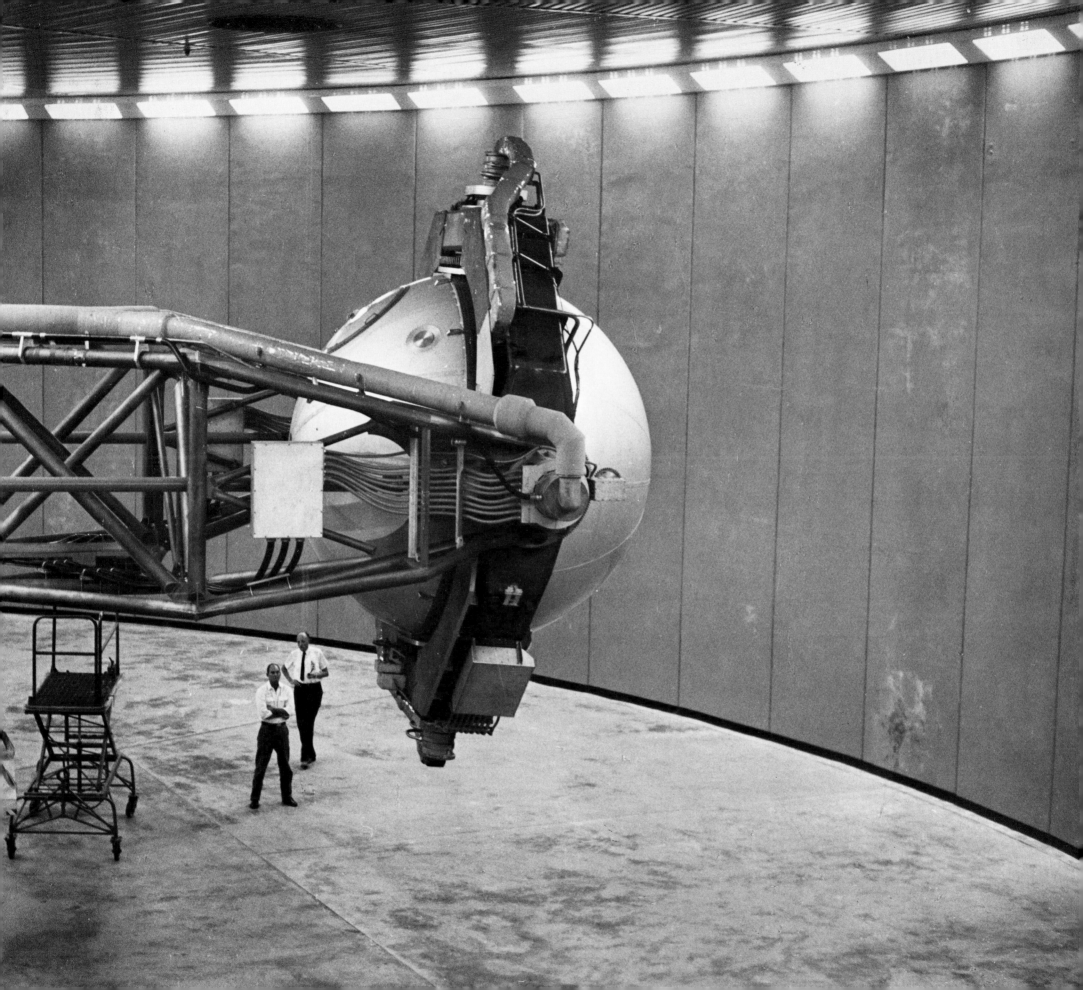

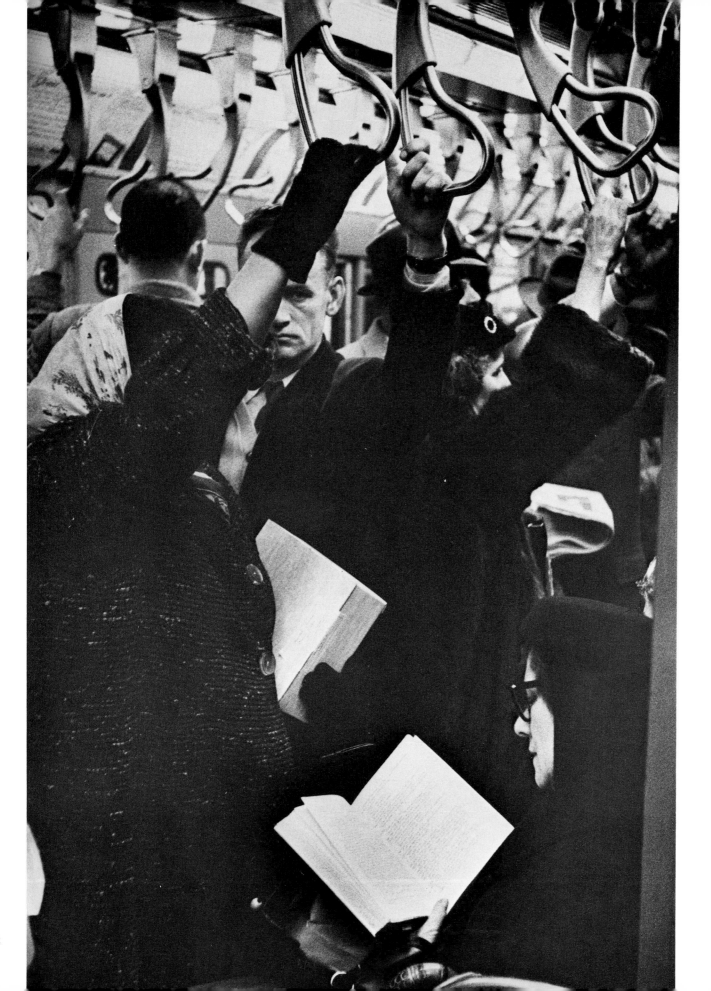

A great city,
a great solitude.

Latin proverb

Human nature
is not a machine
to be built after a model,
and set to do
exactly the work prescribed.

John Stuart Mill

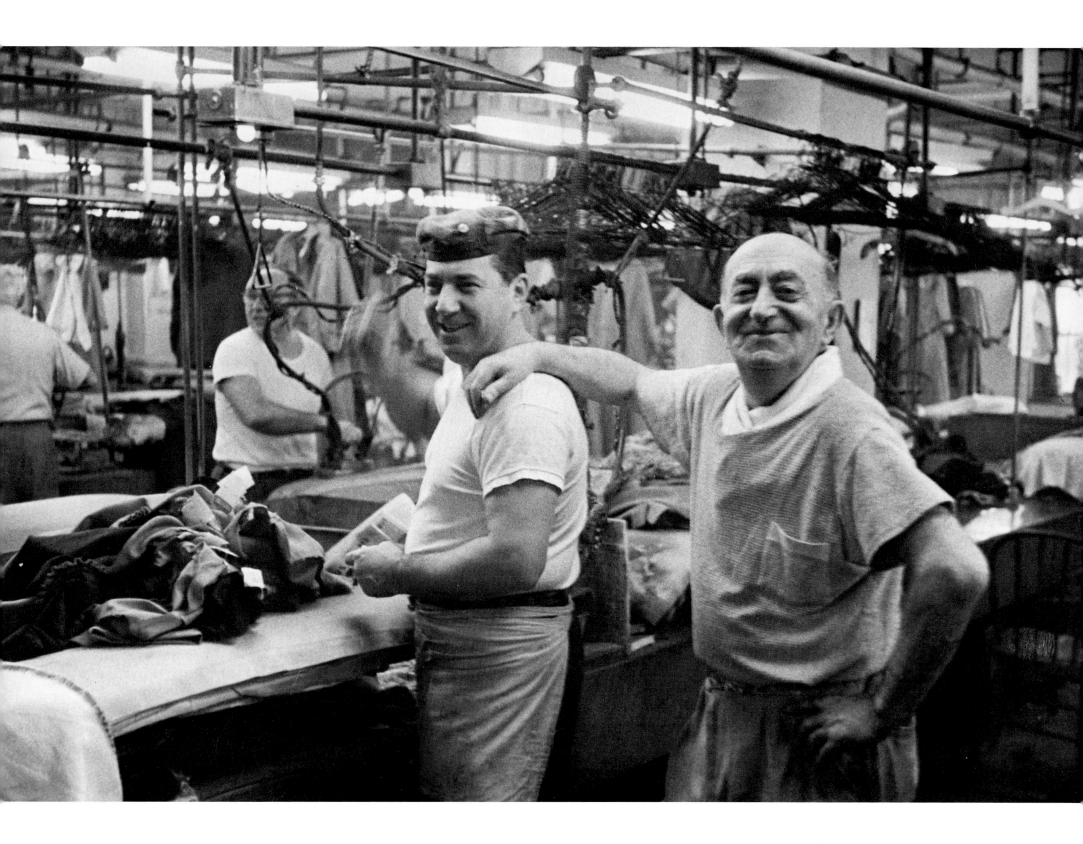

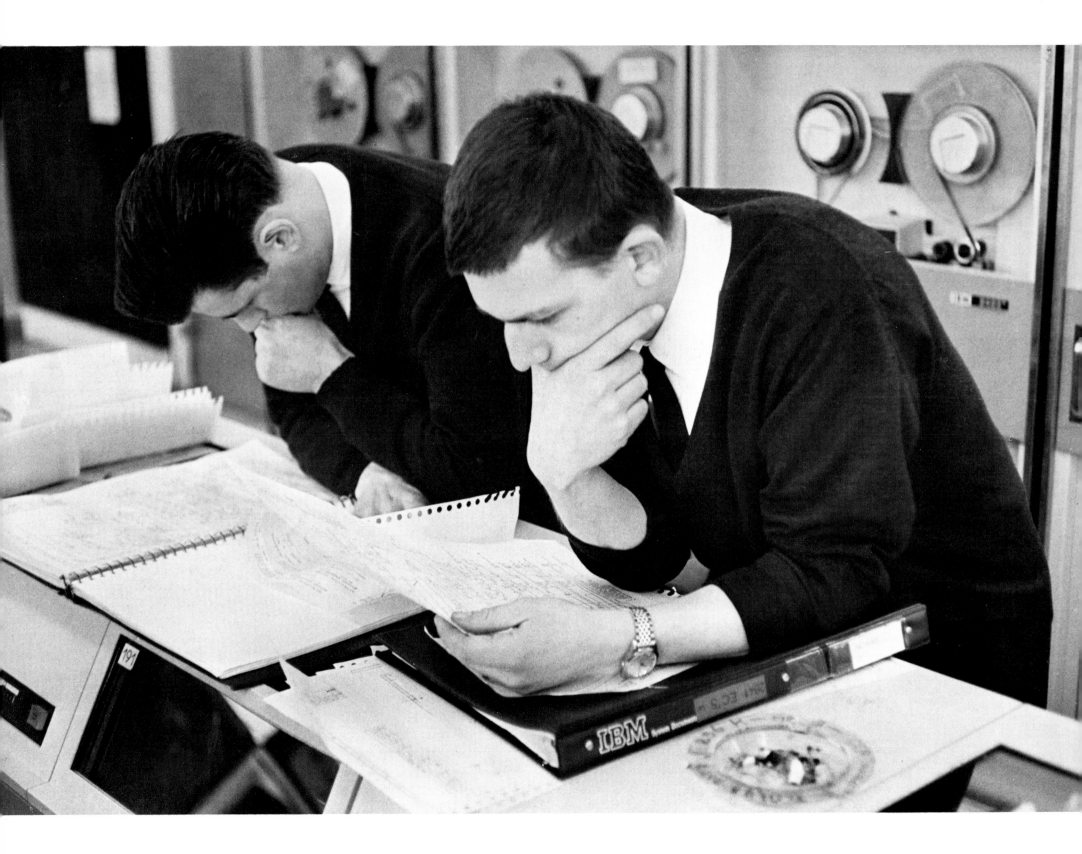

Traditional machines
were only muscles, while
the cybernetic machine
is a total machine capable of
collecting information,
of measuring its own
actions and of executing
the job accordingly.

Albert Ducrocq

45

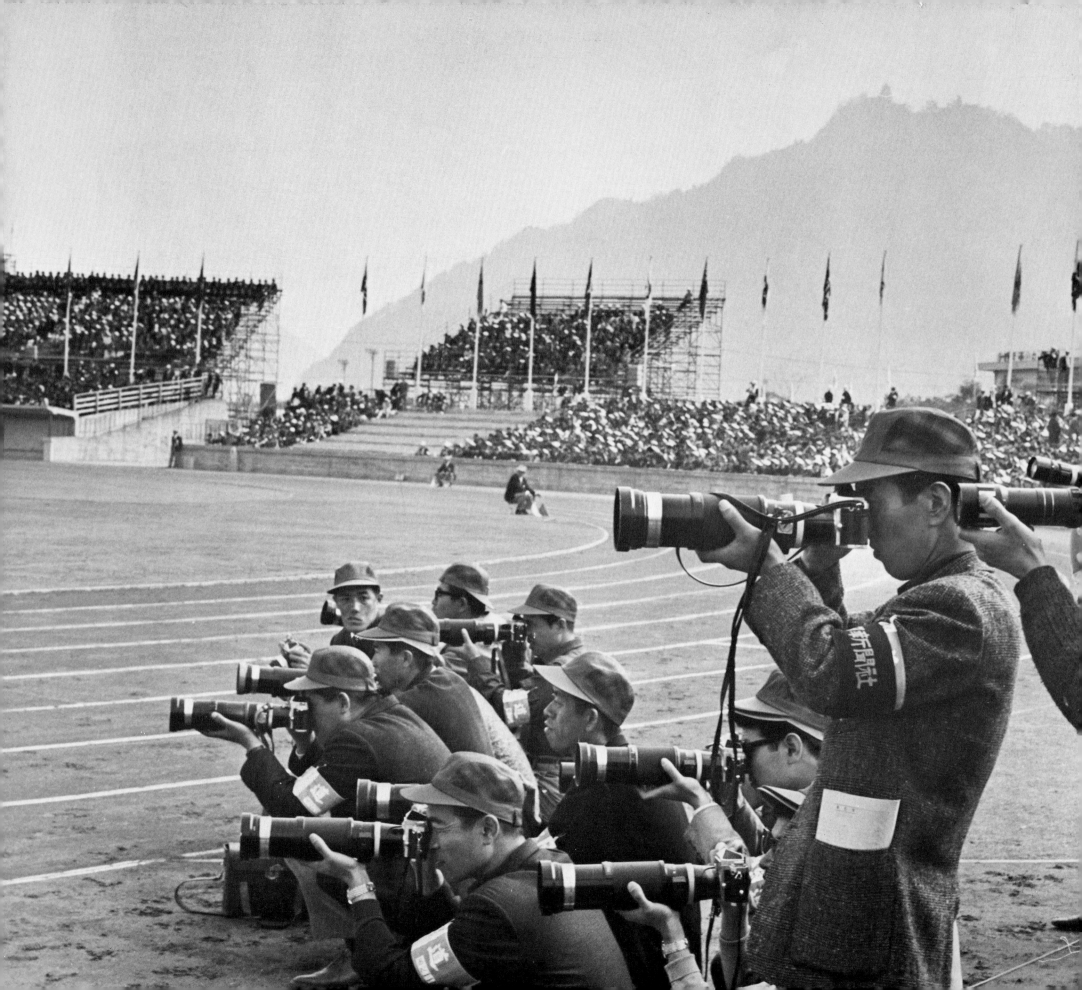

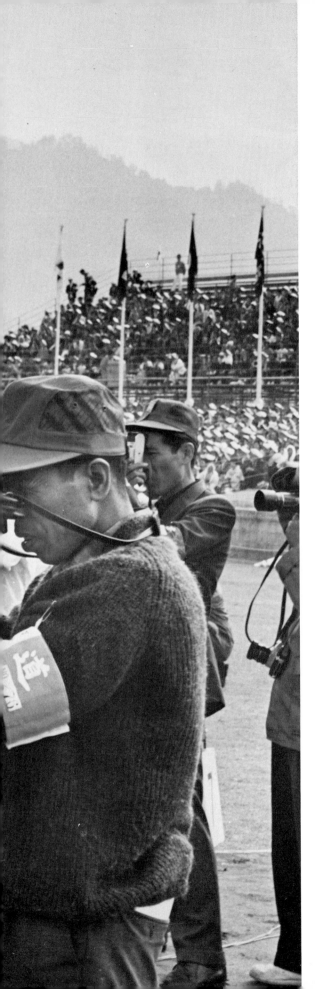

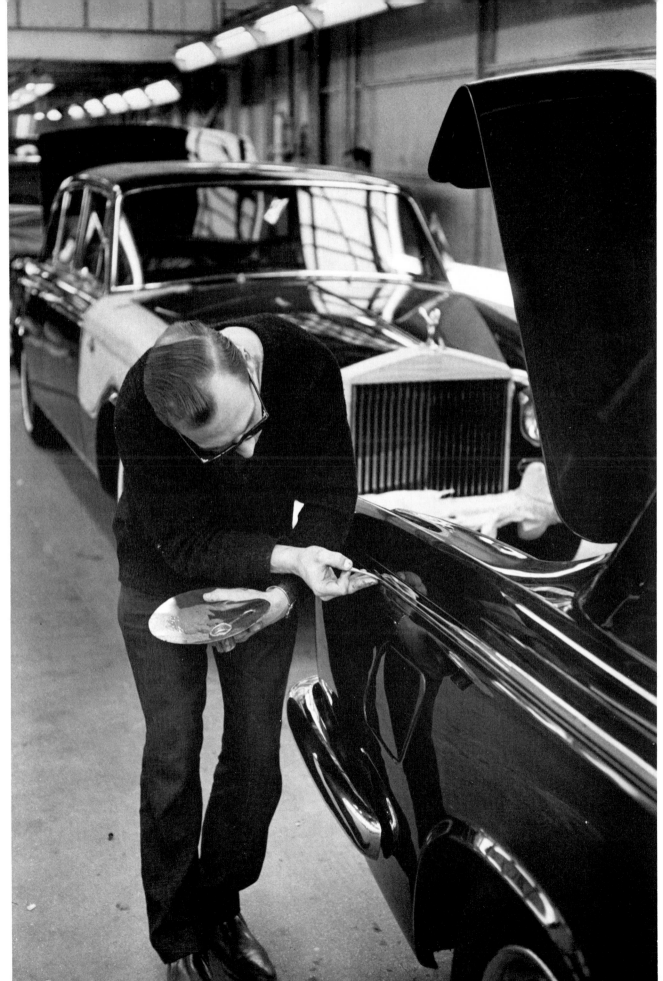

Brother, have you seen the
starlight on the rails?
Have you heard the thunder
of the fast express?

Thomas Wolfe

48

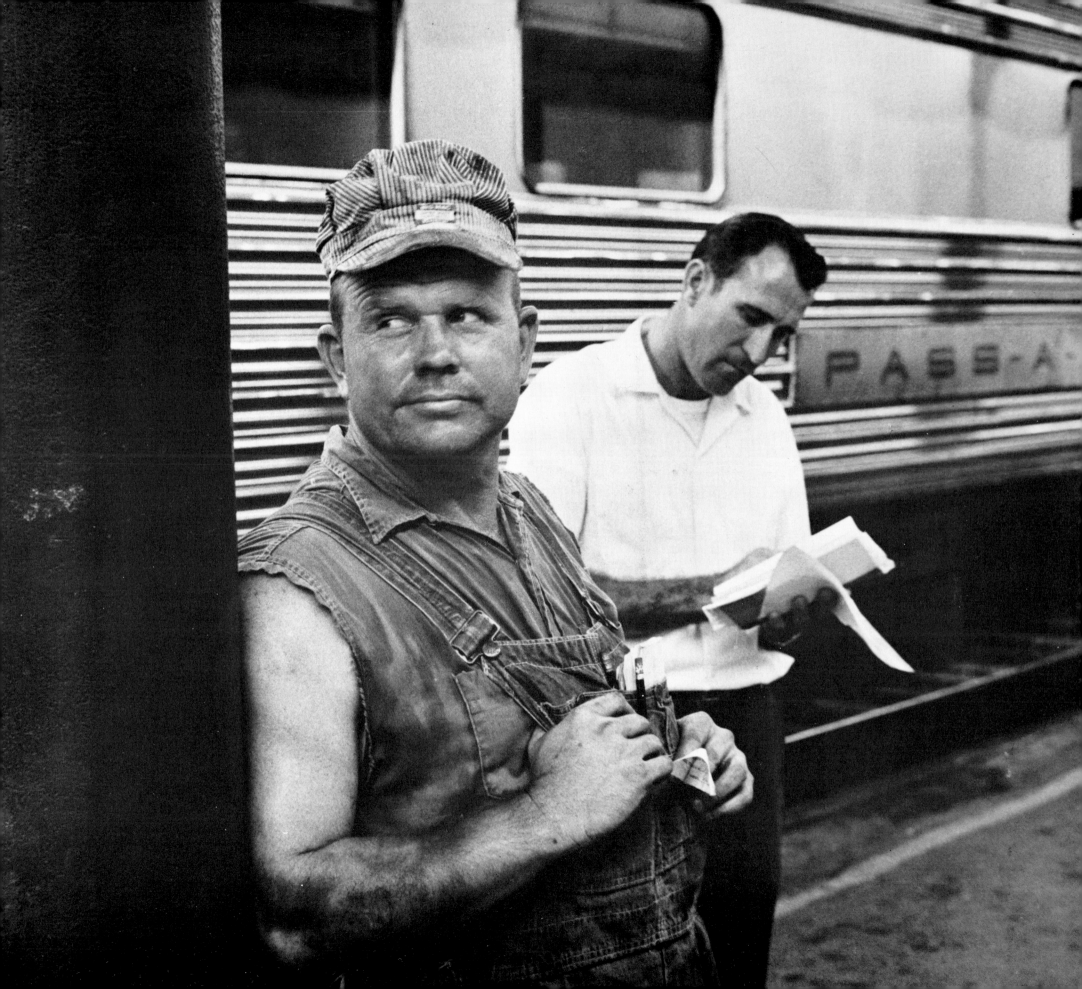

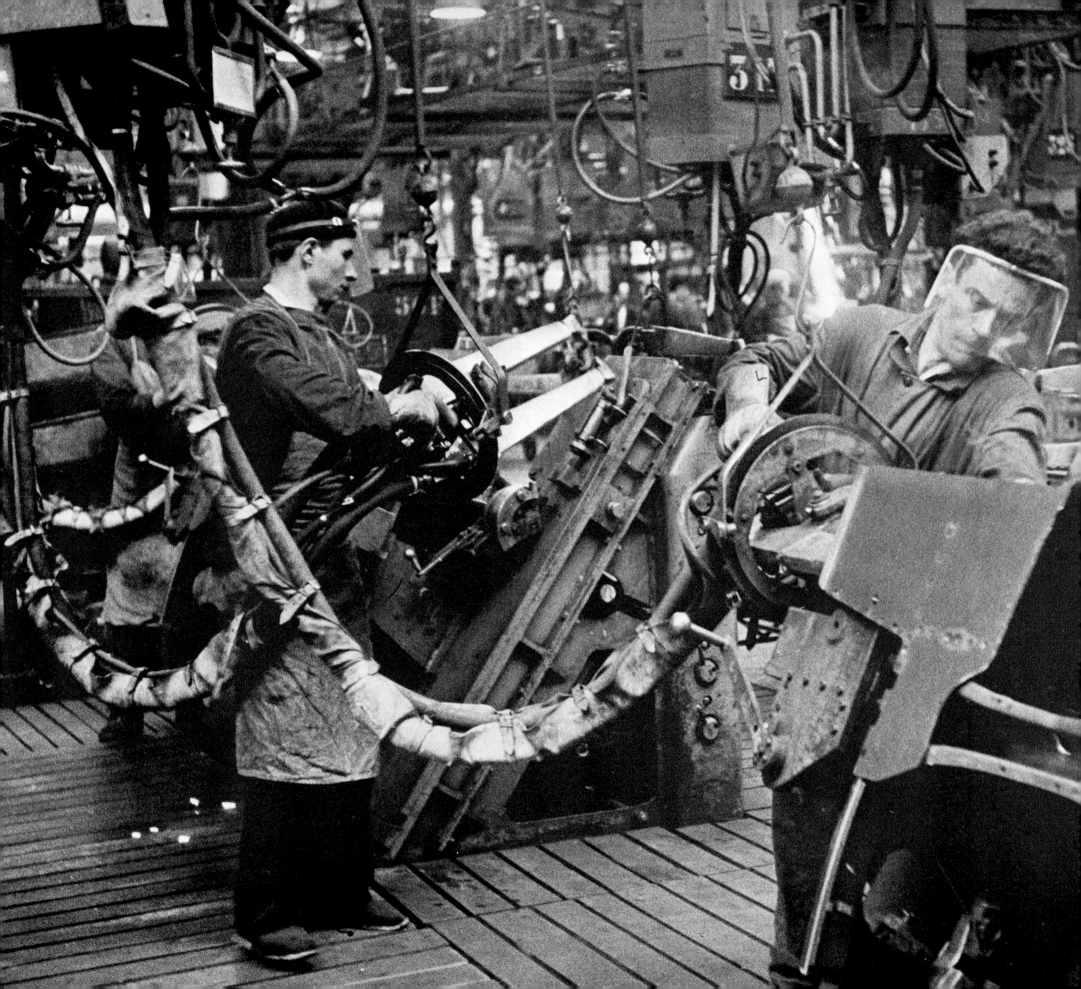

In our excitement for
progress, we have made men
the servants of our
wish to build railroads, to
erect factories, to dig oil wells.

Antoine de Saint-Exupéry

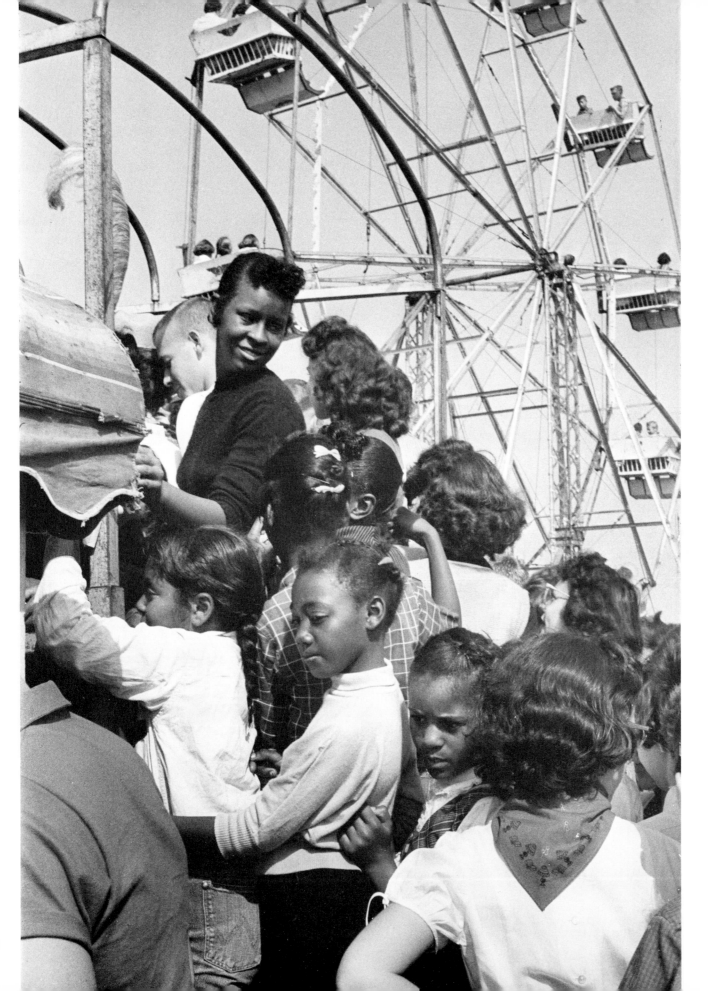

Machines are worshipped
because they are
beautiful, and valued because
they confer power.

Bertrand Russell

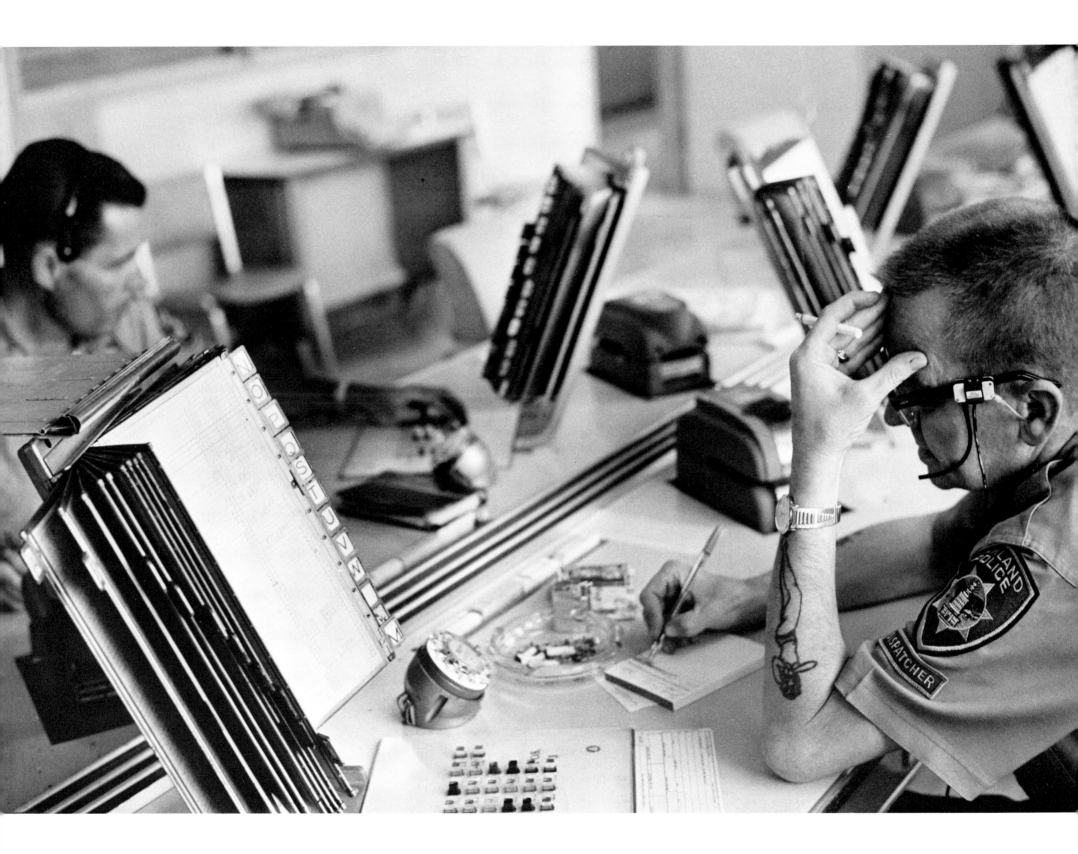

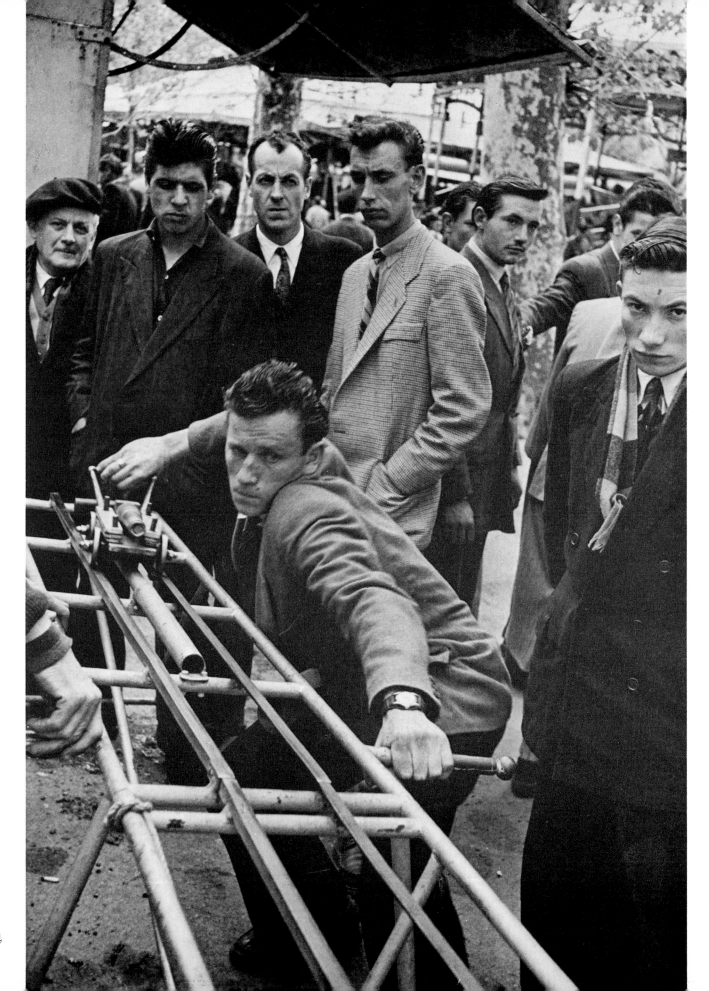

54

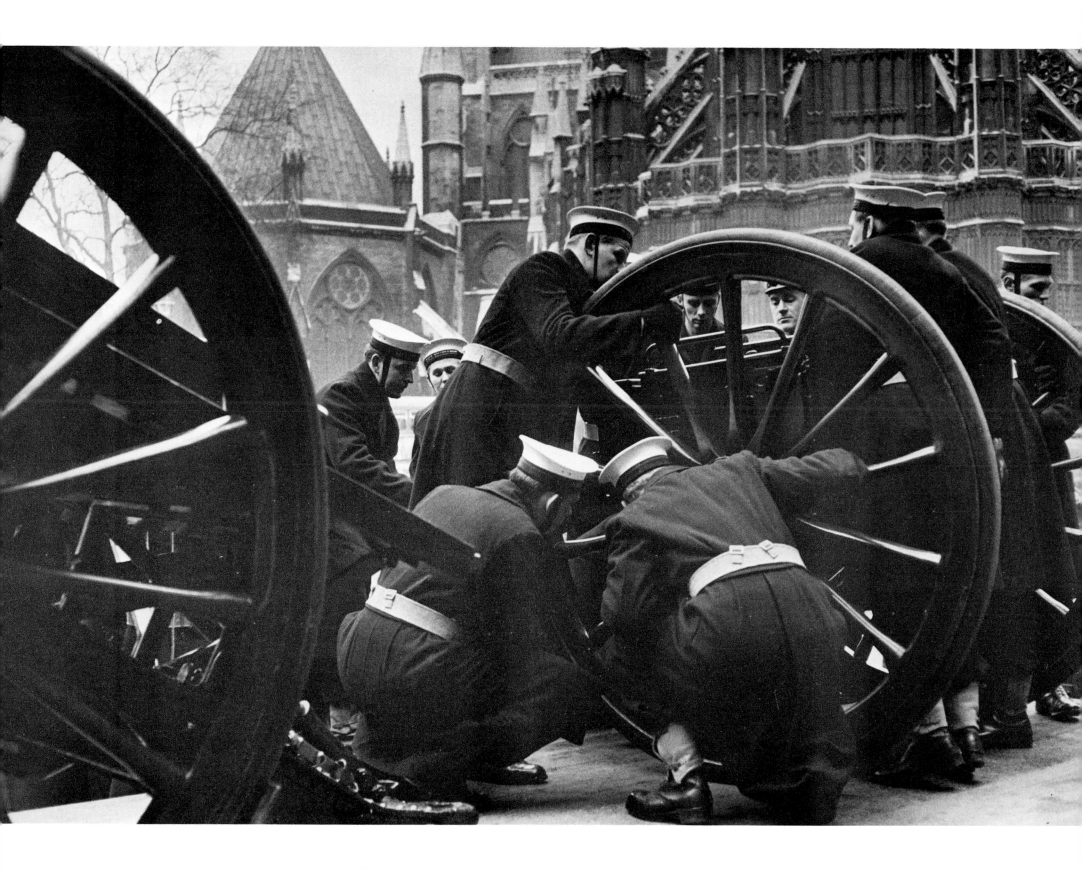

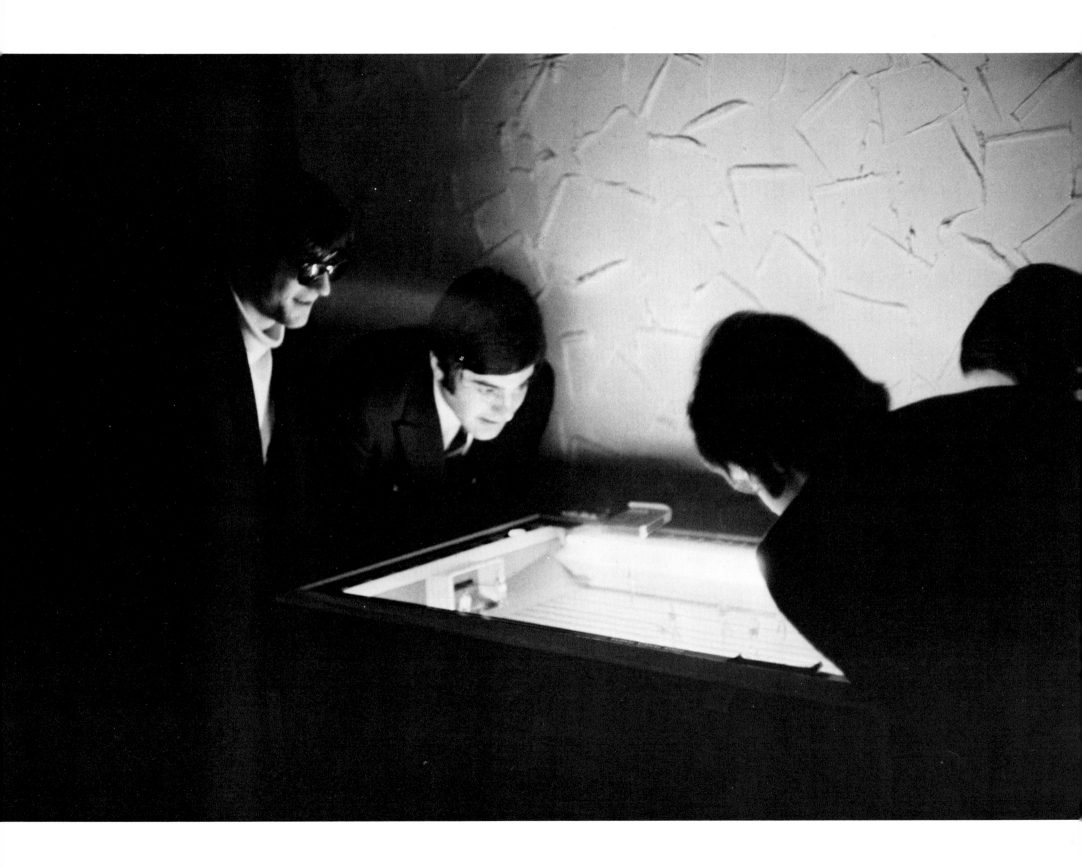

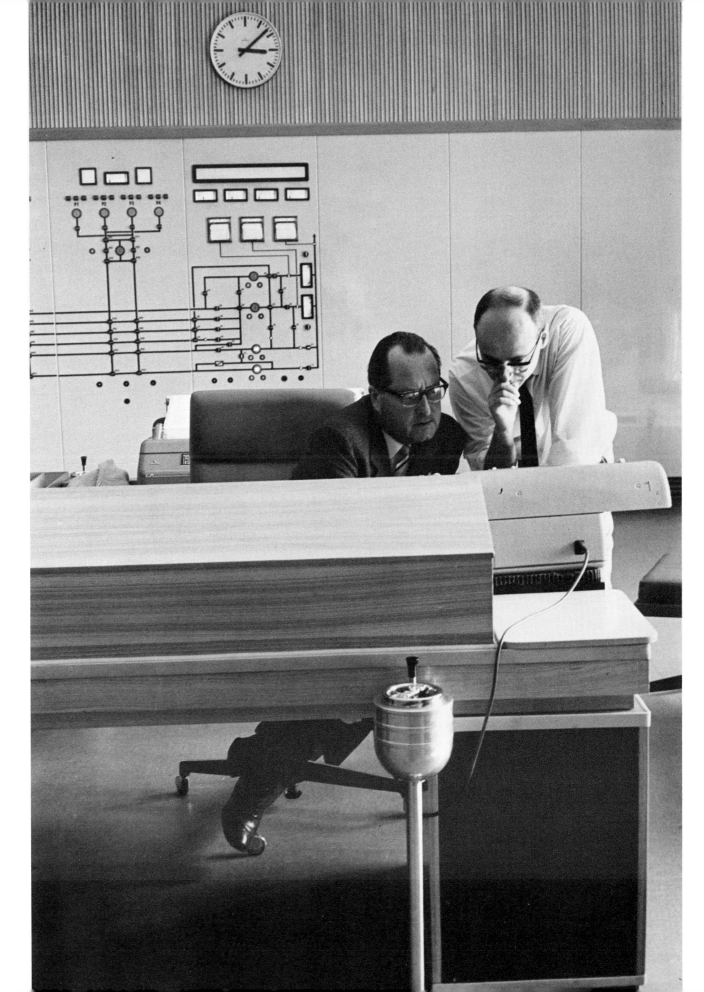

In play there are two
pleasures for your choosing
—the one is winning, and
the other losing.

George Gordon, Lord Byron

57

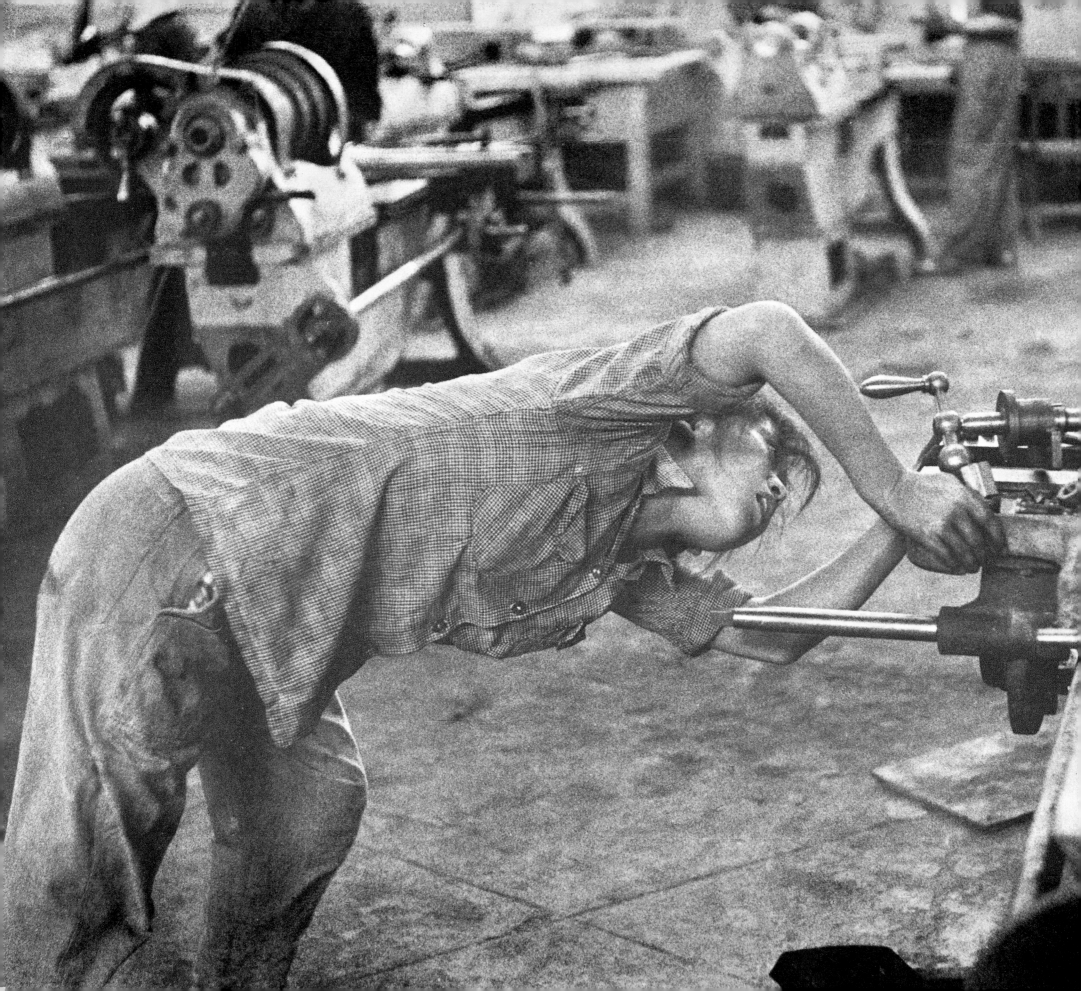

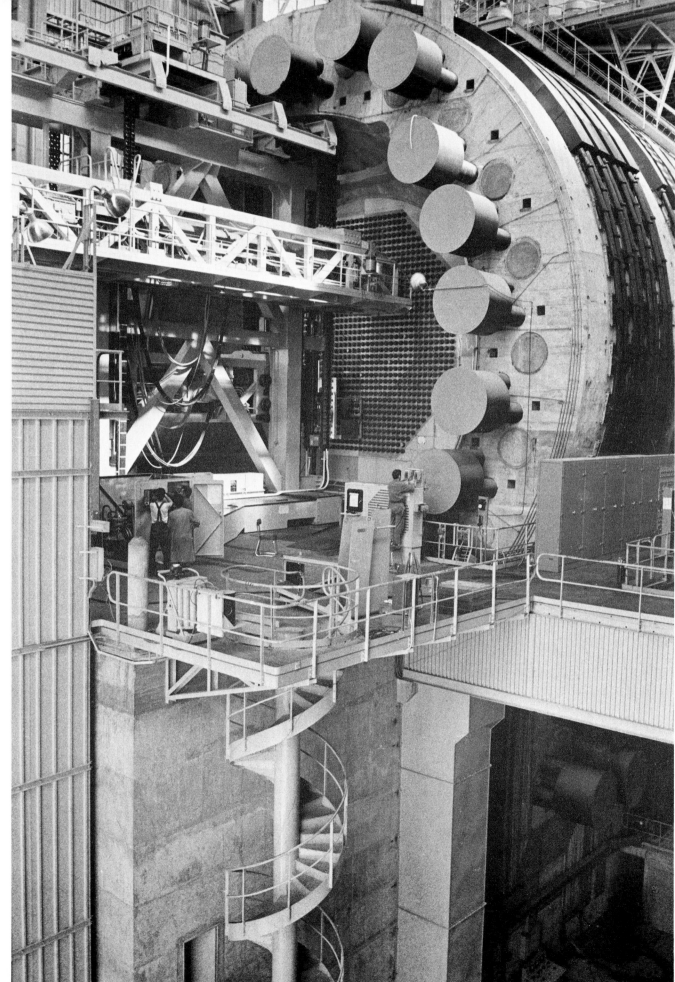

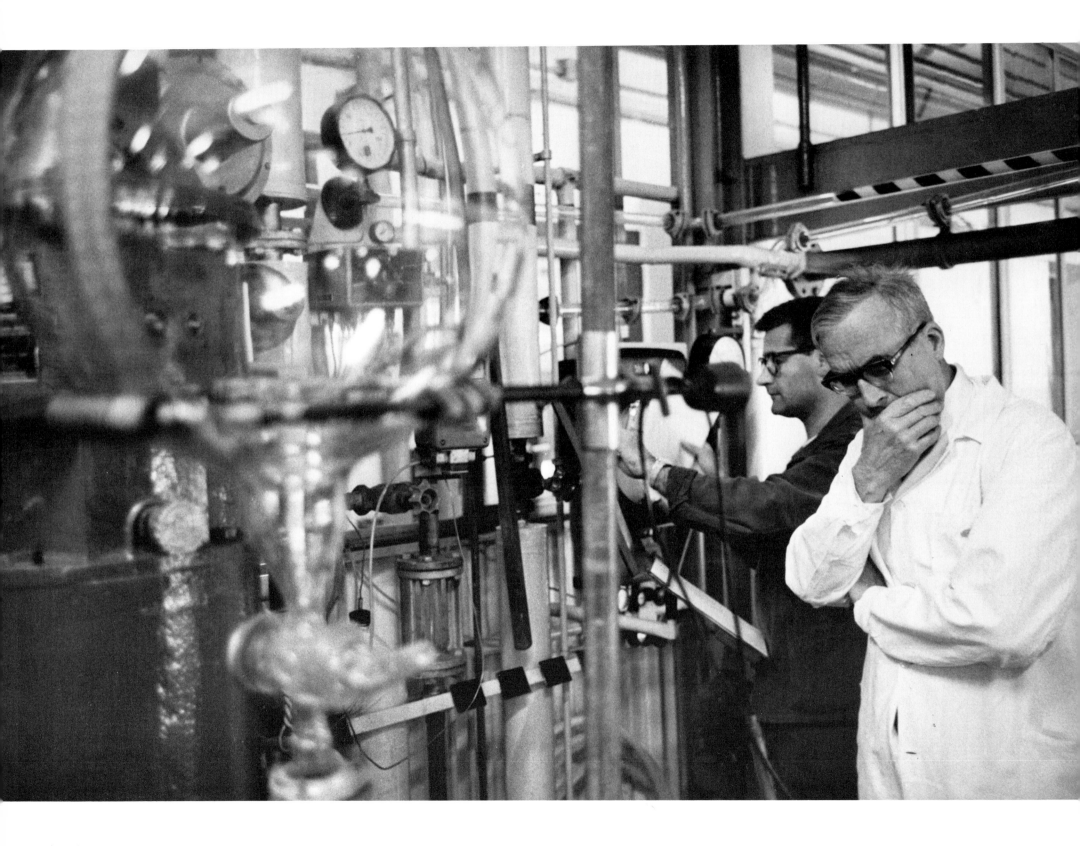

There are children playing
in the street who could
solve some of my
top problems in physics,
because they have modes
of sensory perception that
I lost long ago.

J. Robert Oppenheimer

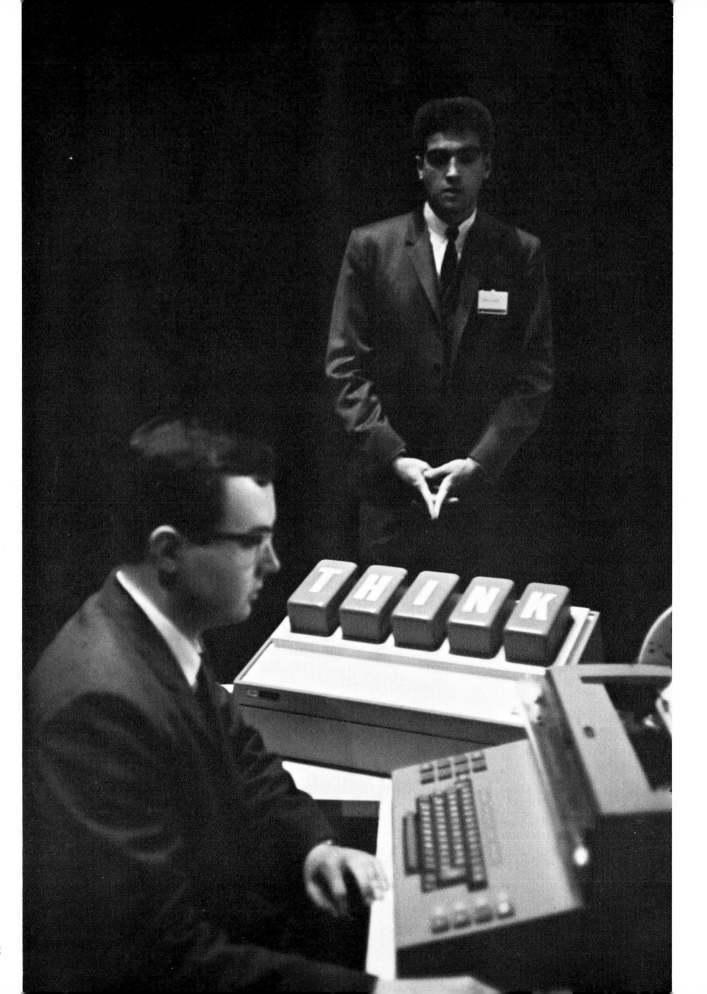

If every instrument could accomplish its own work, obeying or anticipating the will of others ... if the shuttle would weave and the pick touch the lyre without a hand to guide them, chief workmen would not need servants, nor masters slaves.

Aristotle

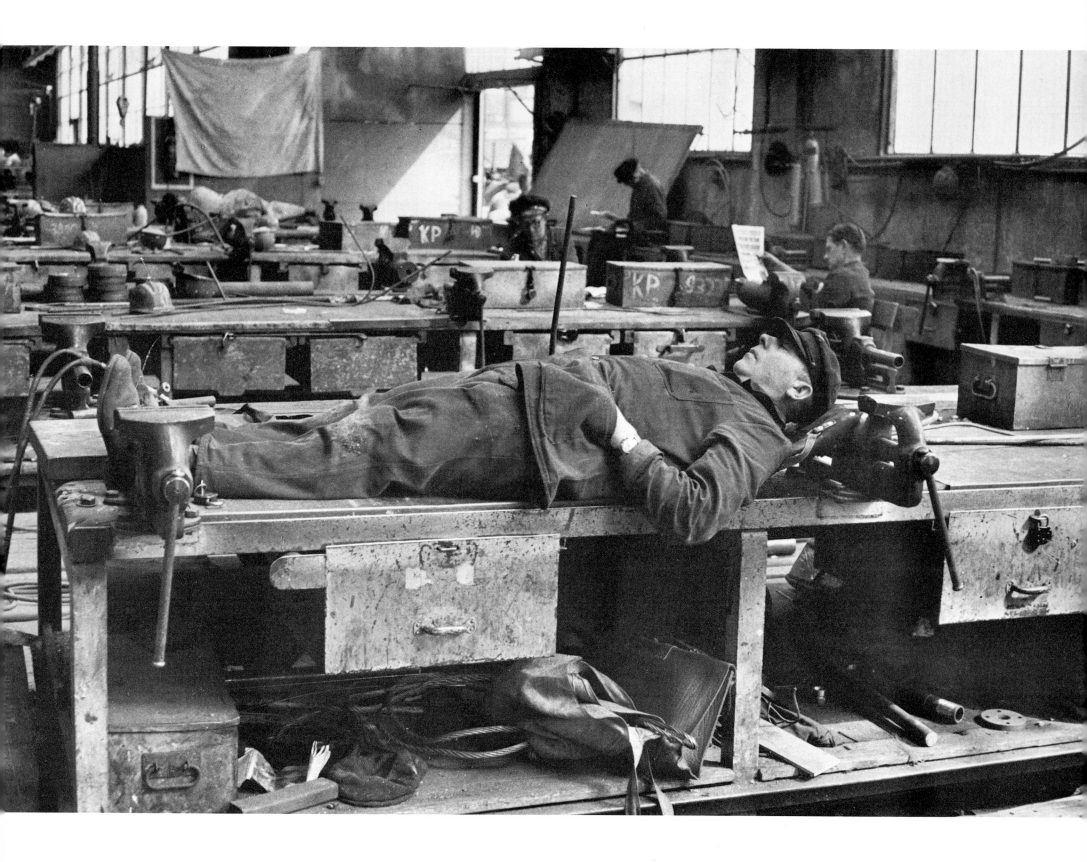

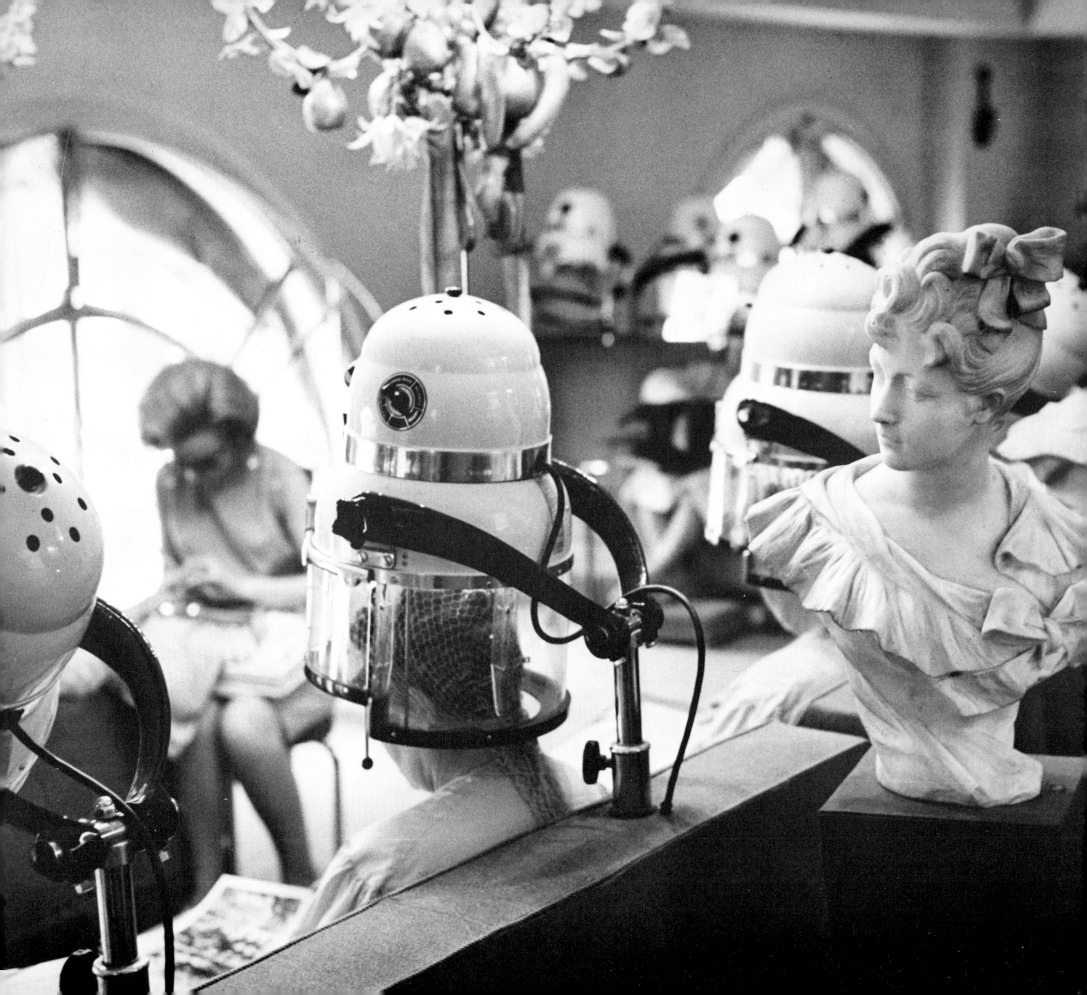

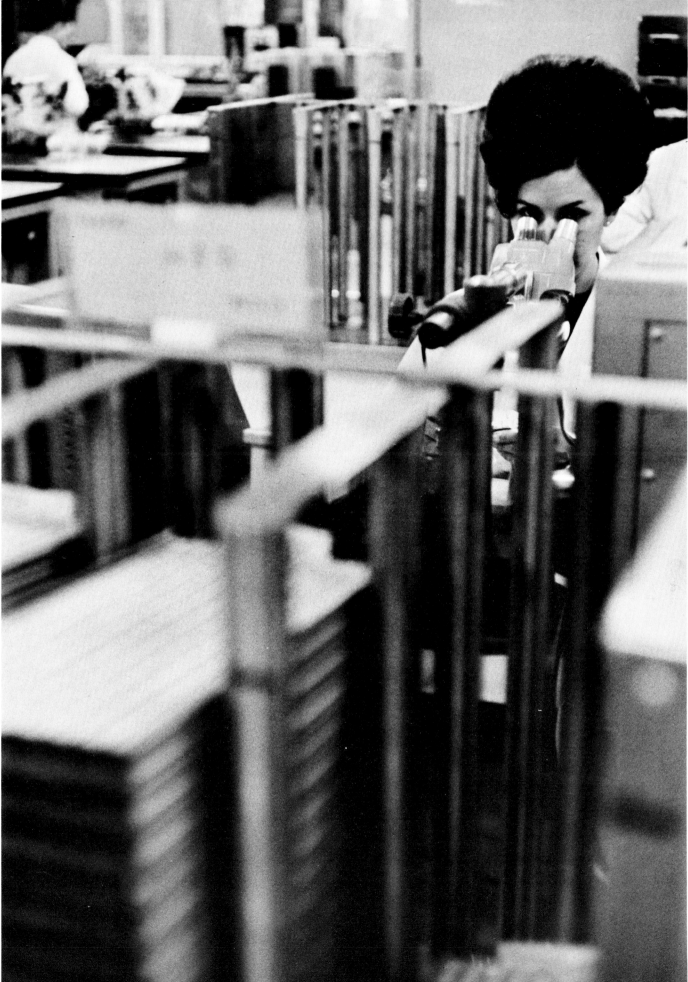

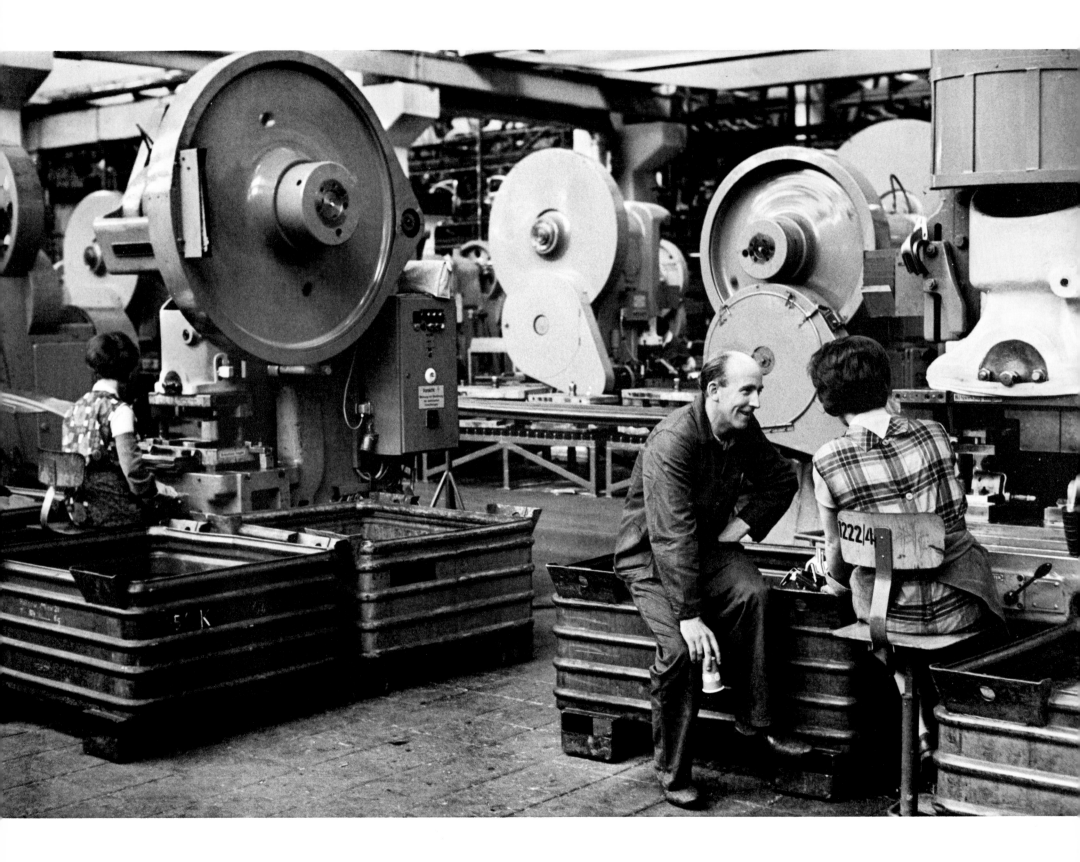

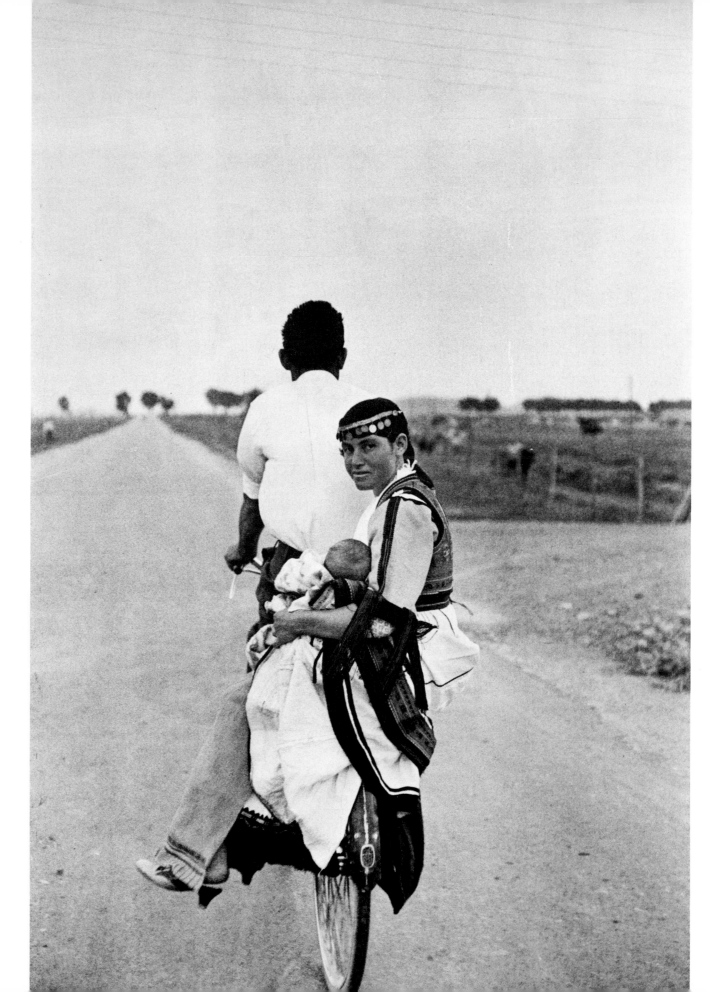

The joy of living to the beat
of human life and not
to the rhythm enforced by
the time-keeper!

Simone Weil

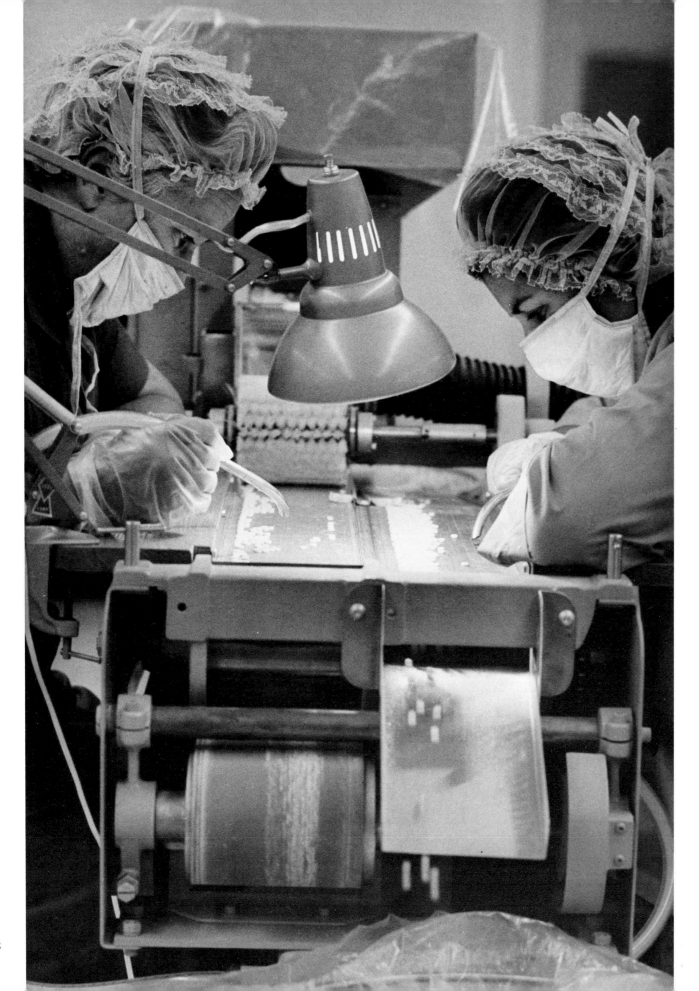

Of a human creature,
you can make either a
tool or a man;
you cannot have both
at the same time; men were
not created to work
with the exactitude of tools,
to be precise or perfect
in all their actions.

John Ruskin

Cease from grinding, ye
women who toil at the mill;
sleep late, even if the
crowing cocks announce
the dawn. For Demeter has
ordered the Nymphs to
perform the work of your
hands, and they, leaping
down on the top of the
wheel, turn its axle which,
with its revolving
spokes, turns the heavy
concave Nisyrion millstones.

Antipater

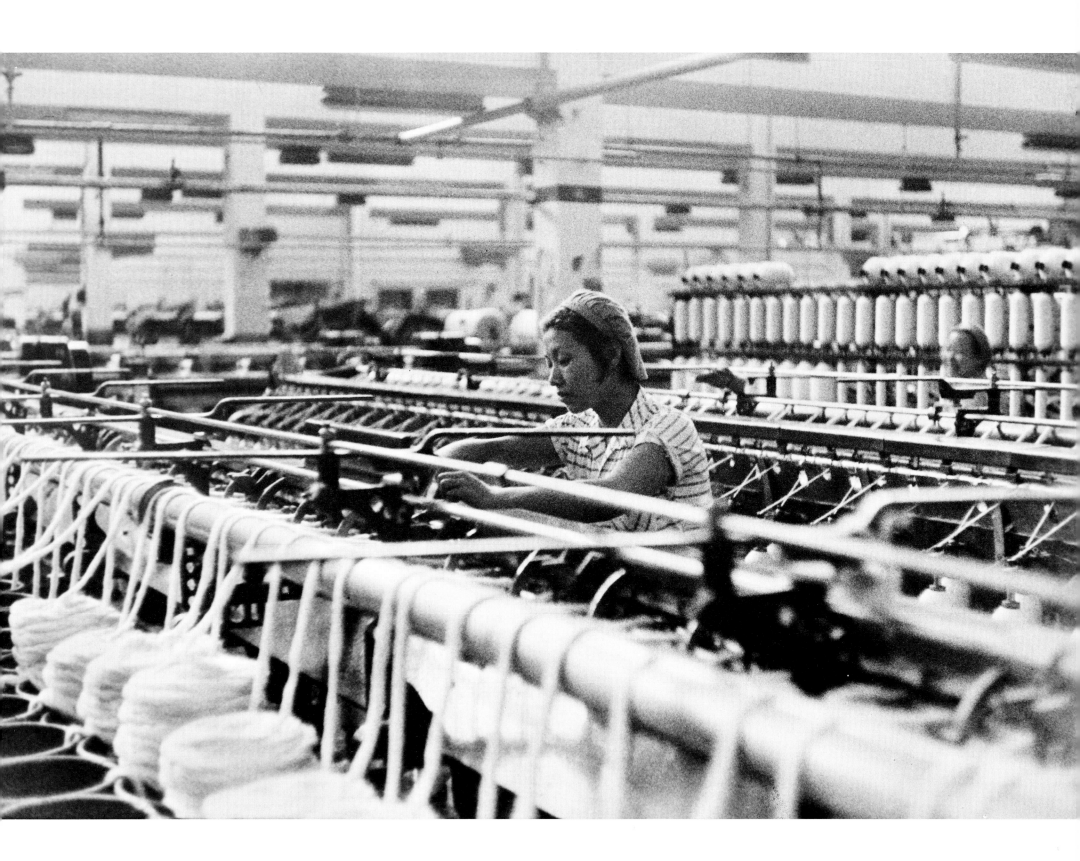

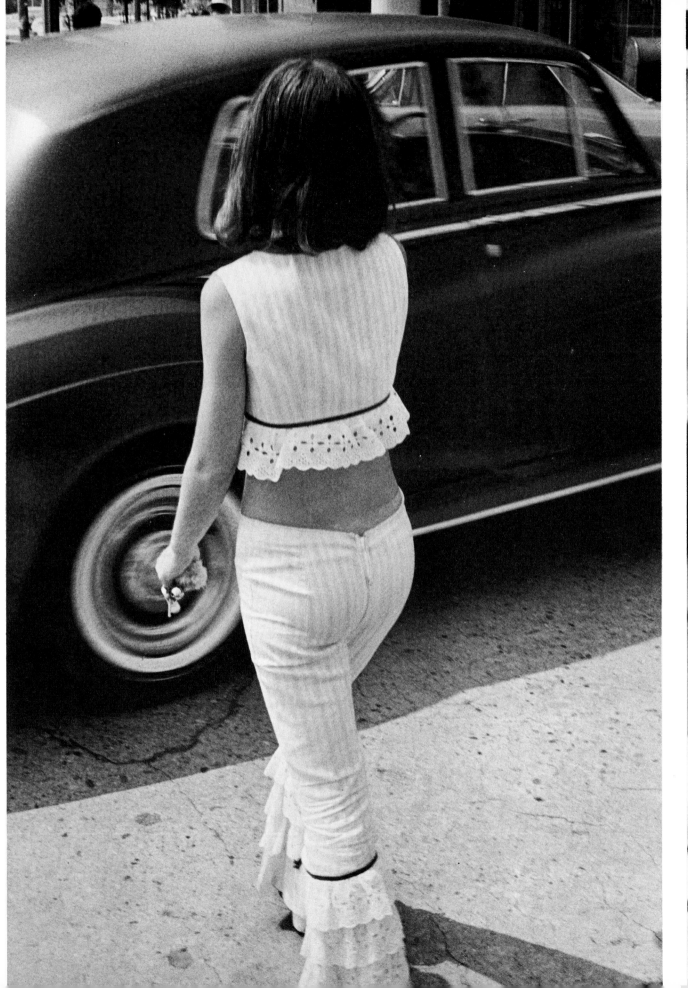
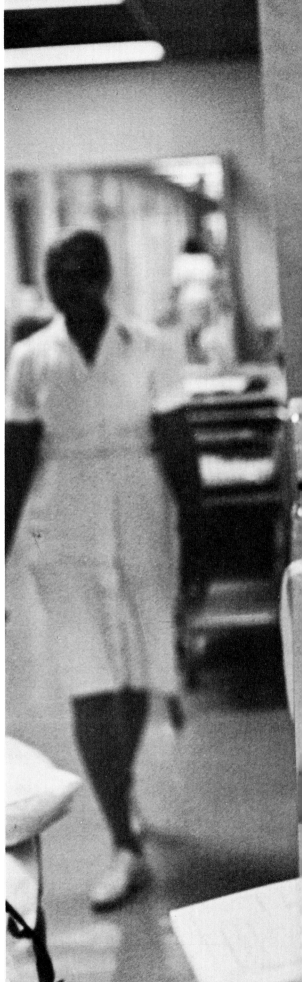

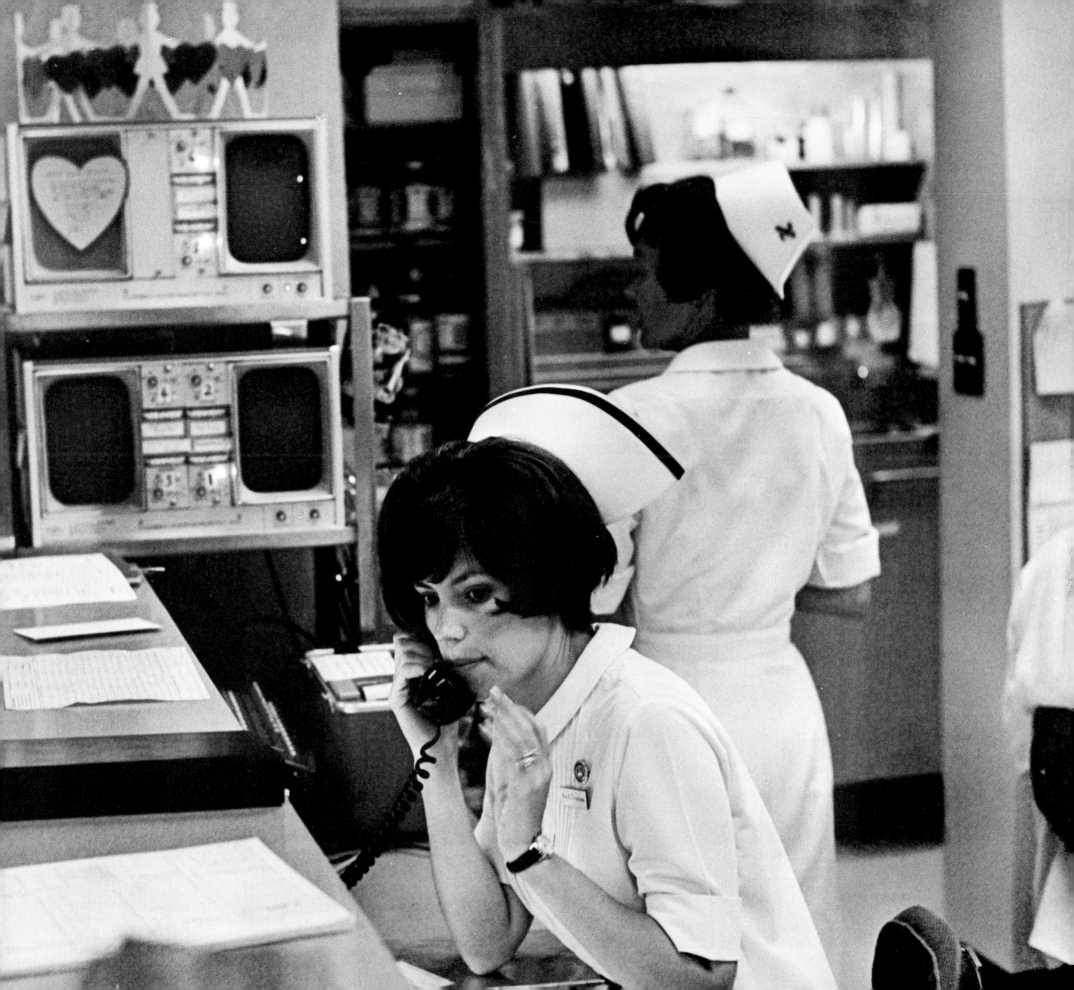

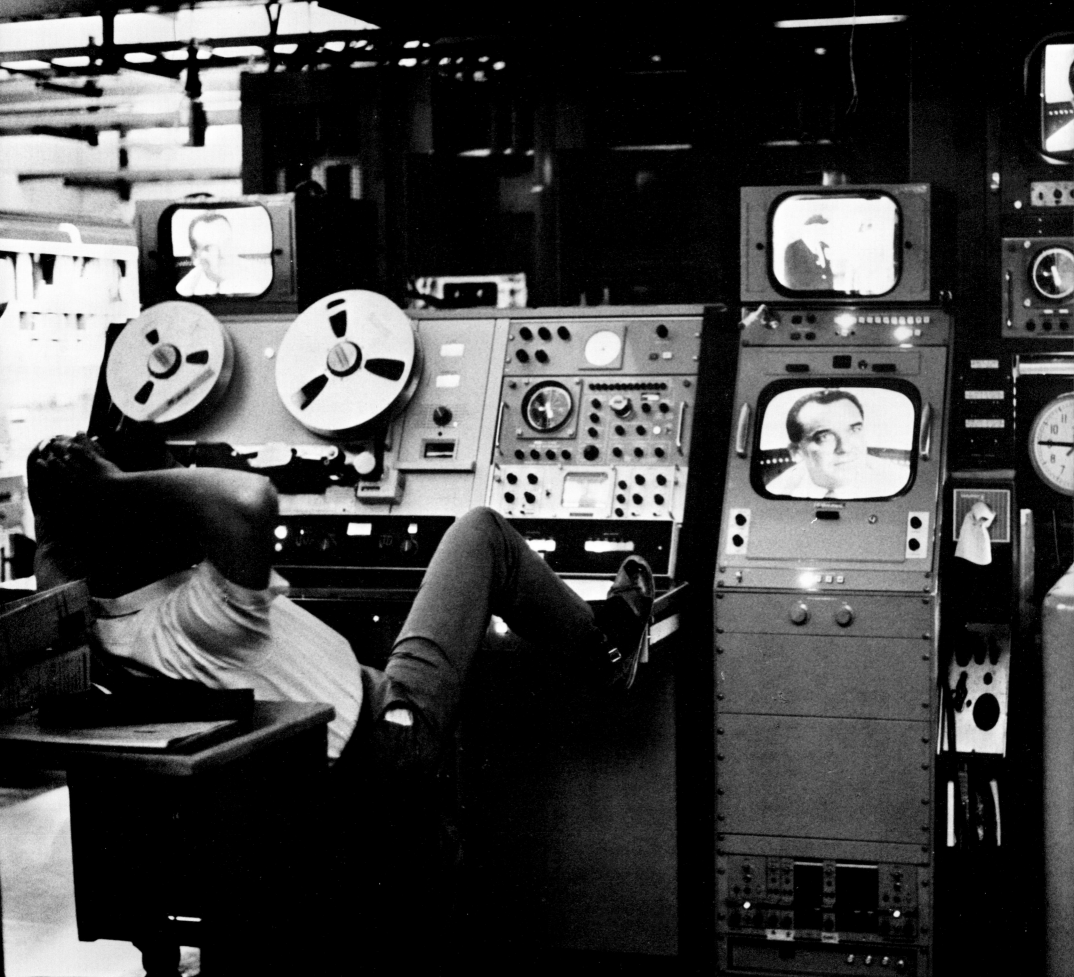

The machine is such a
capital event in human
history that we must ascribe
to it a major role in the
conditioning of man's
mind, a role equally as
decisive and largely more
extended than that of
the conquering hegemonies of
past ages, which through
wars replaced one people by
another. The machine
opposes not one people to
another, but a new world to
an old world, for all people.

Le Corbusier

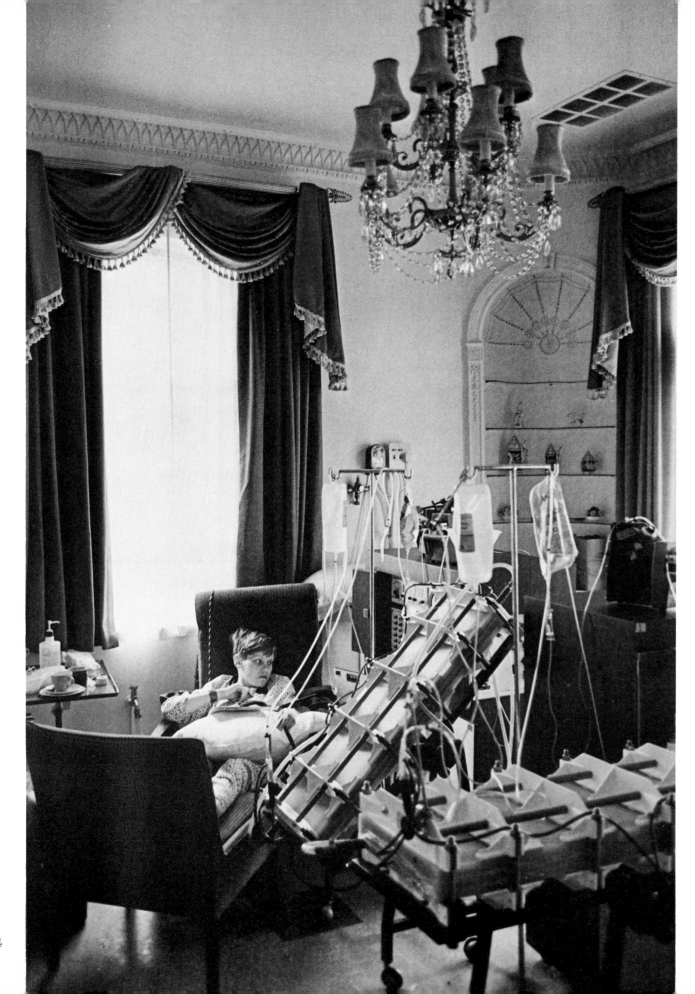

A machine is but a
complex tool. He that invents
a machine augments
the power of man and the
well-being of mankind.

Henry Ward Beecher

Why has not man
a microscopic eye?
For this plain reason,
man is not a fly.

Alexander Pope

74

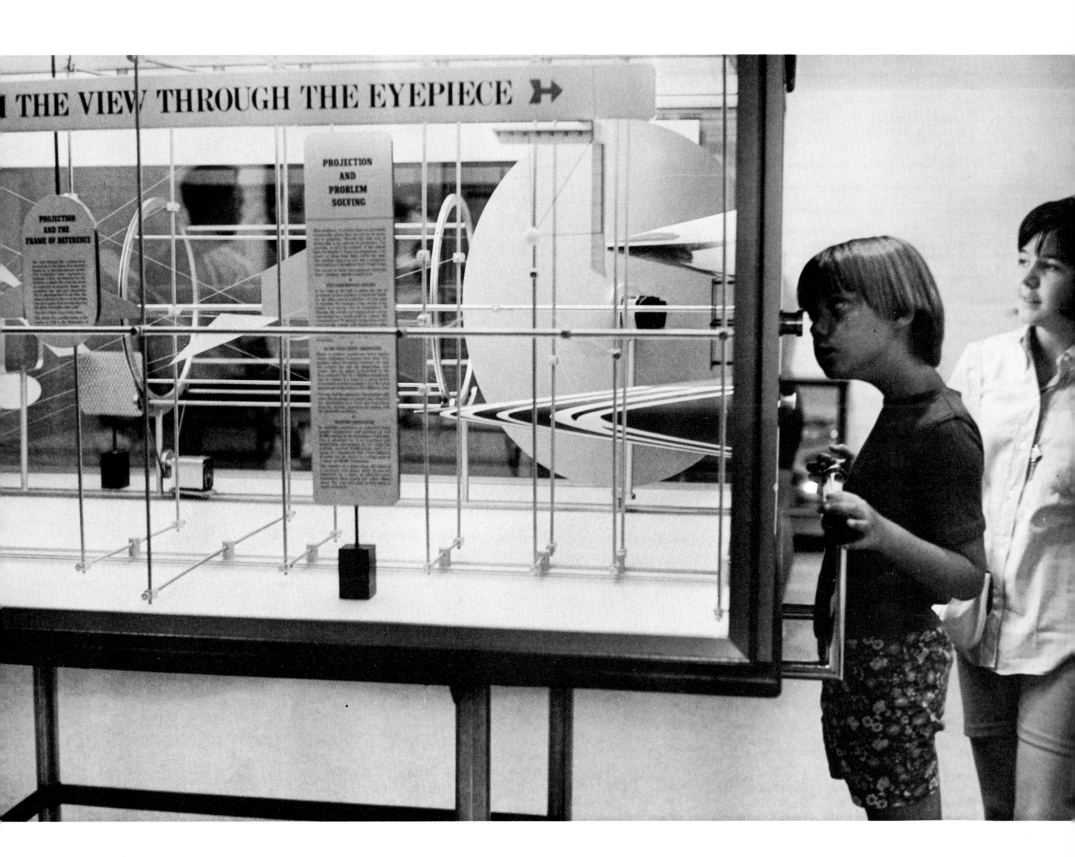

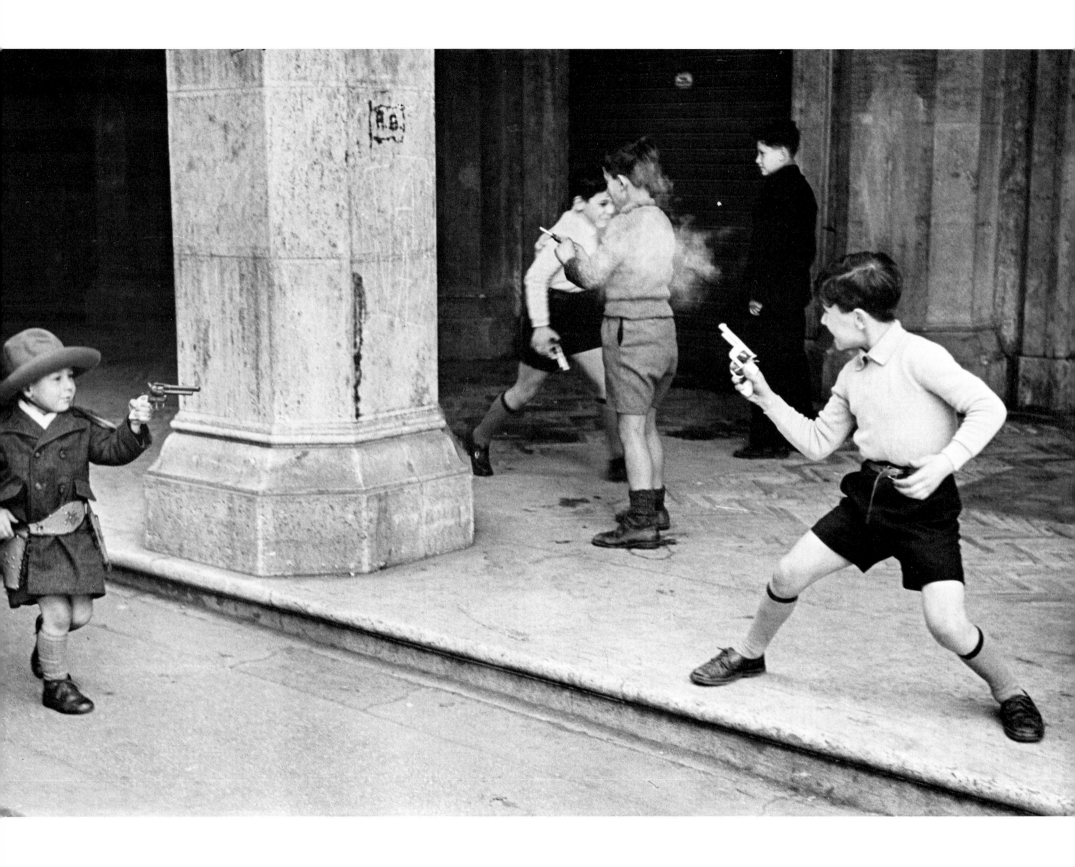

The most incomprehensible
thing about the world
is that it is comprehensible.

Albert Einstein

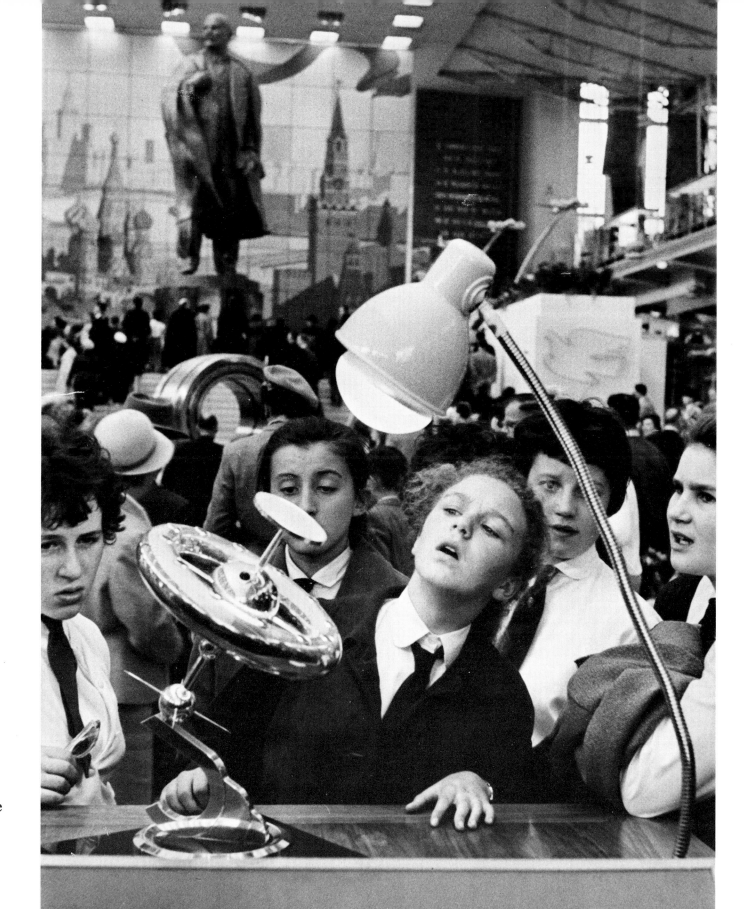

LE SOLEIL CONSTITUE LA SOURCE D' ÉNERGIE
POUR L' APPAREILLAGE DU SPOUTNIK

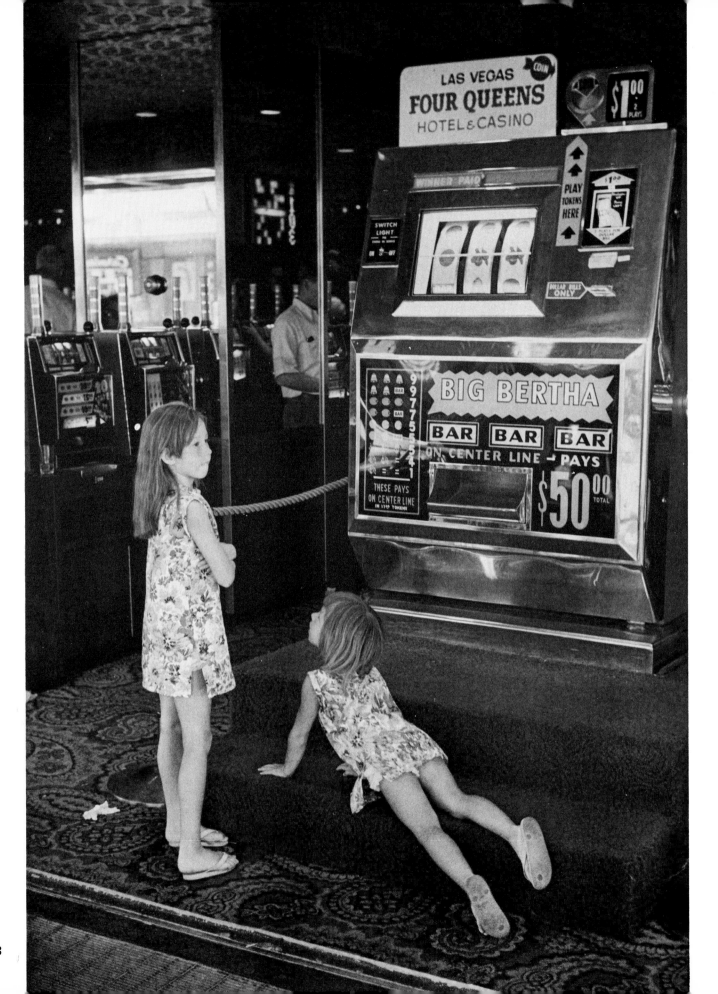

Let us remember that we are
the first generation
in all the thousands of years
to look upon machines,
and let us forgive
man's infatuation with them.

Le Corbusier

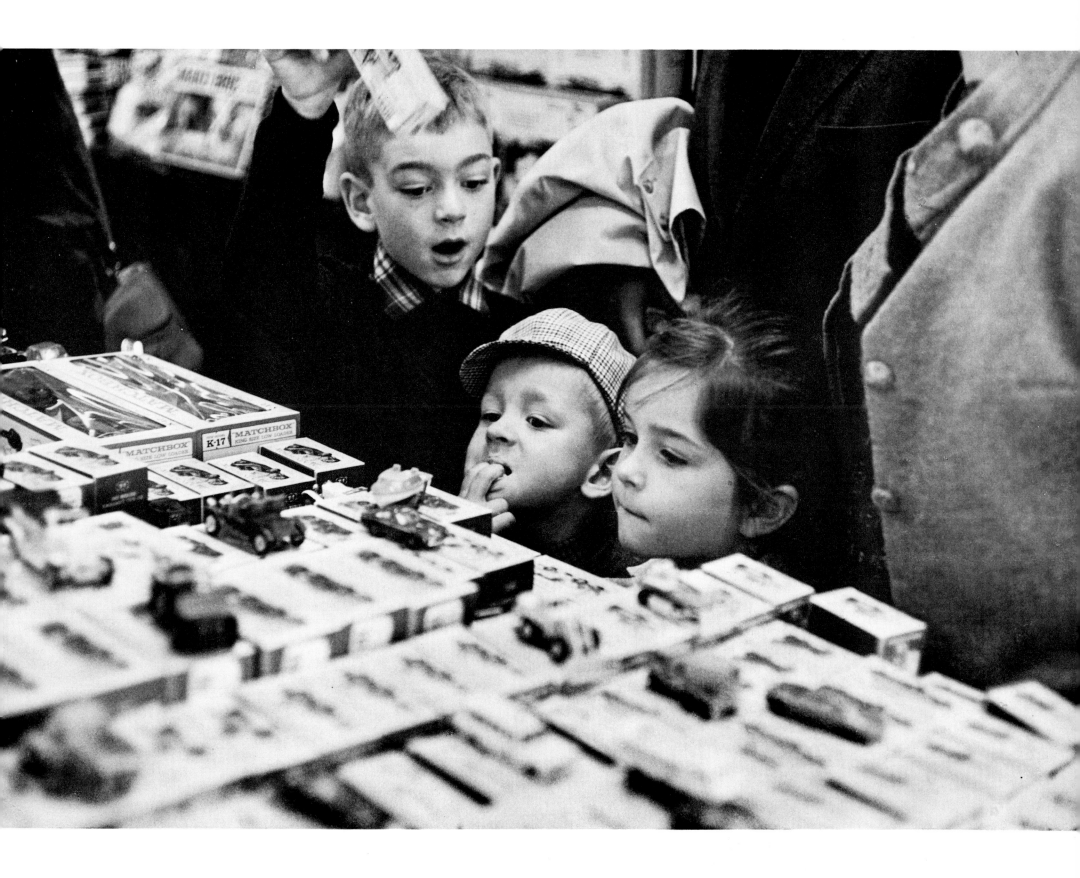

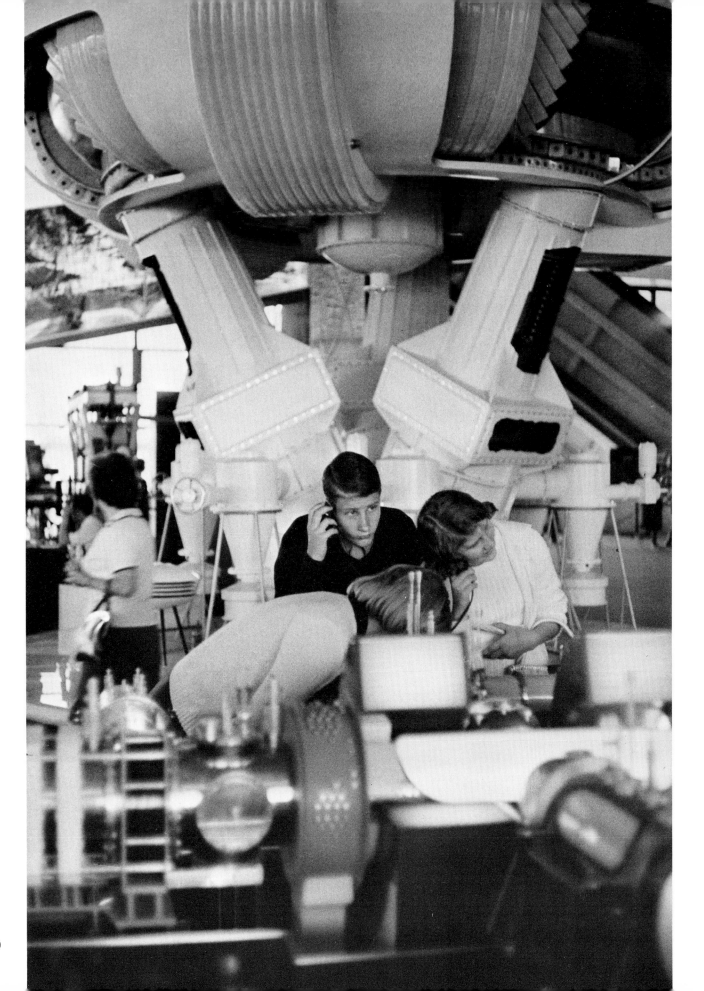

What we want to know
cannot be squeezed
out of a machine by throwing
in the raw materials
at one end and grinding out
results at the other.

Jacques Barzun

I like the dreams
of the future better than
the history of the past.

Thomas Jefferson

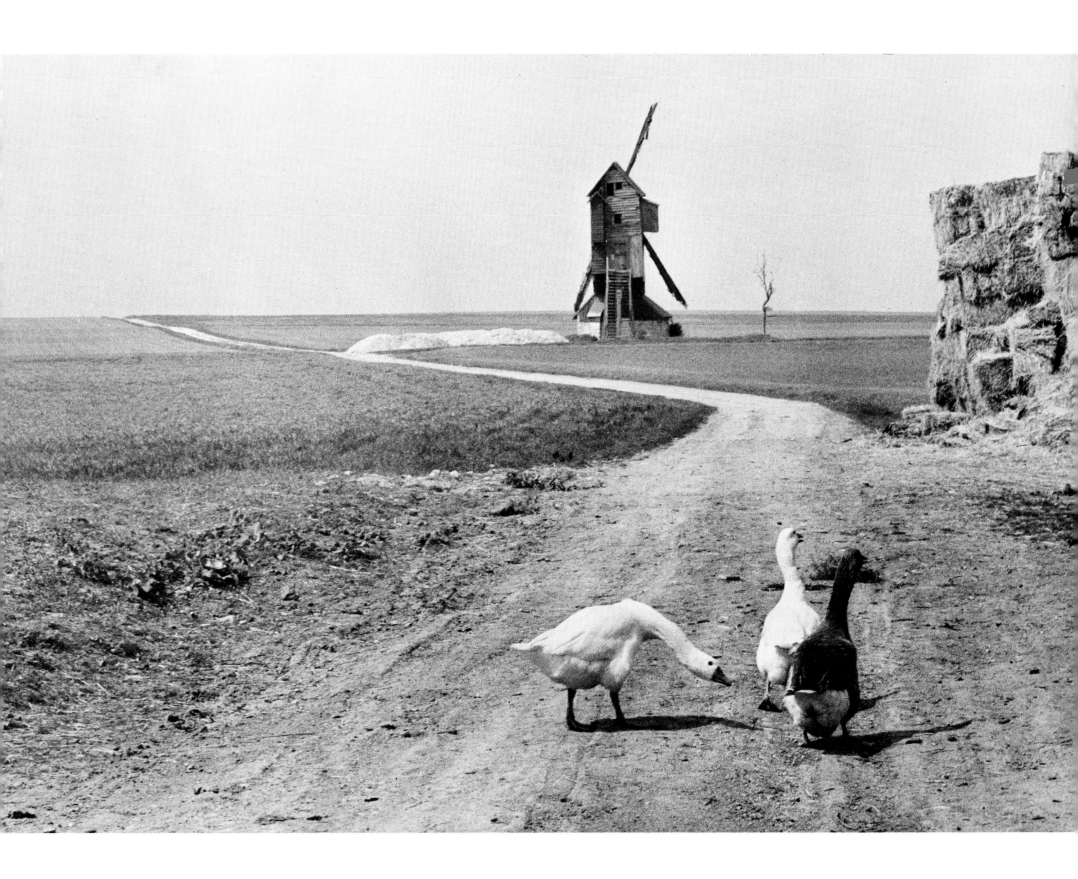

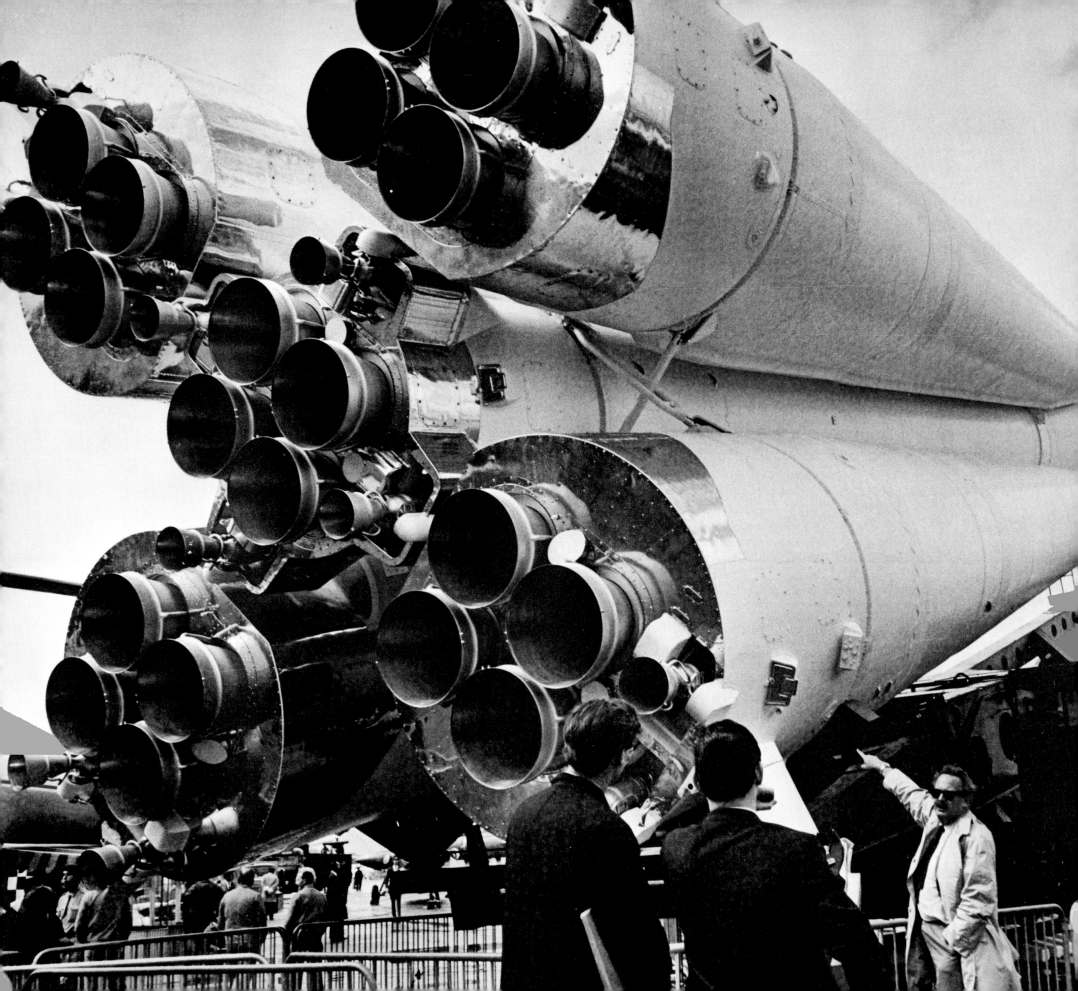

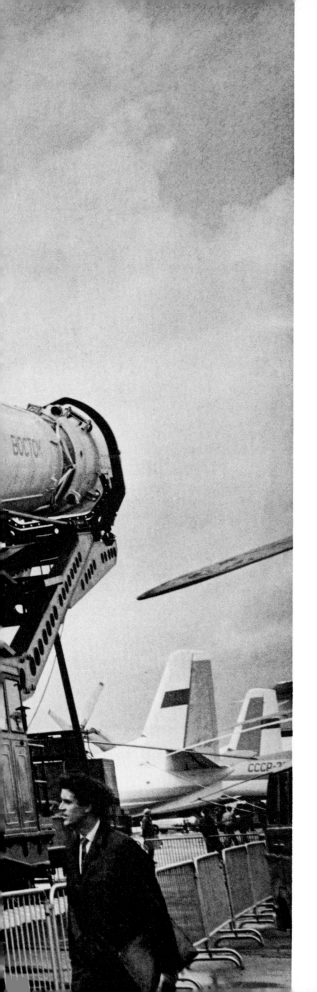

Armed with his machinery
man can live, can fly,
can see atoms like a gnat...
He can peer into Uranus
with his telescope, or knock down
cities with his fists of powder.

Ralph Waldo Emerson

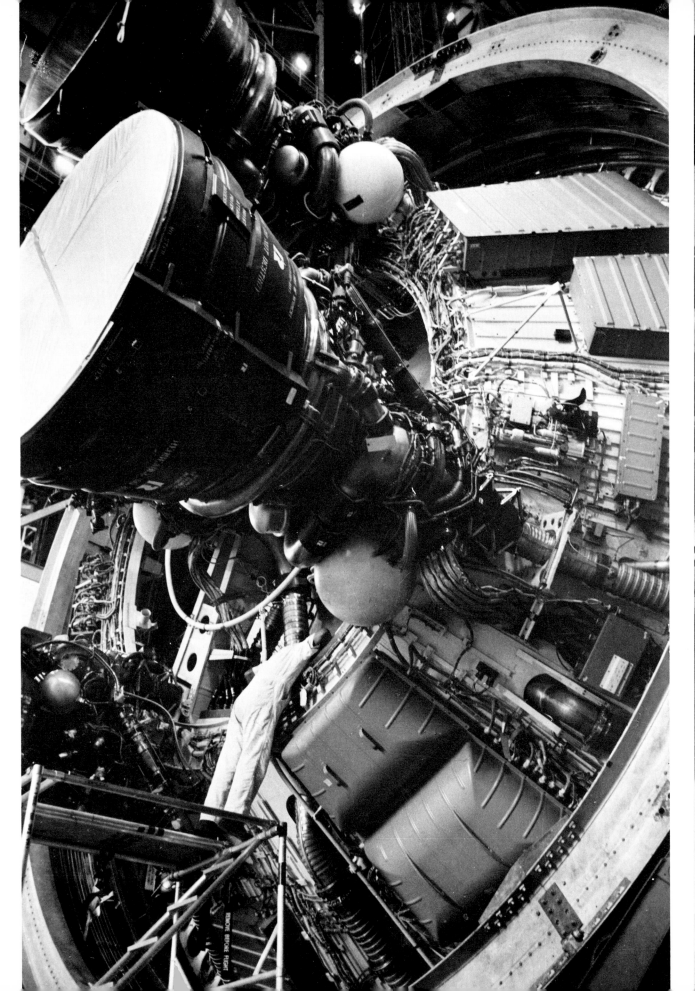

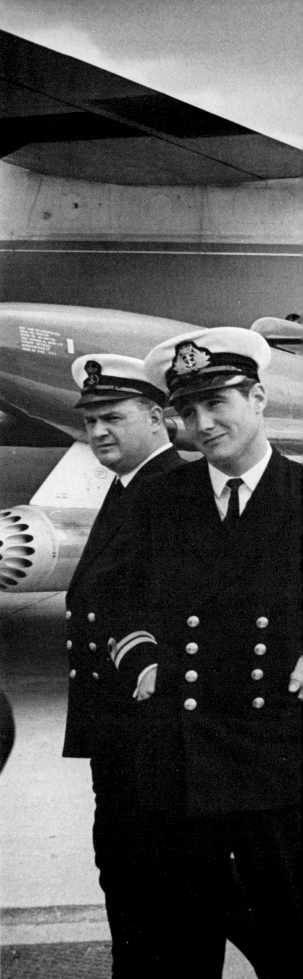

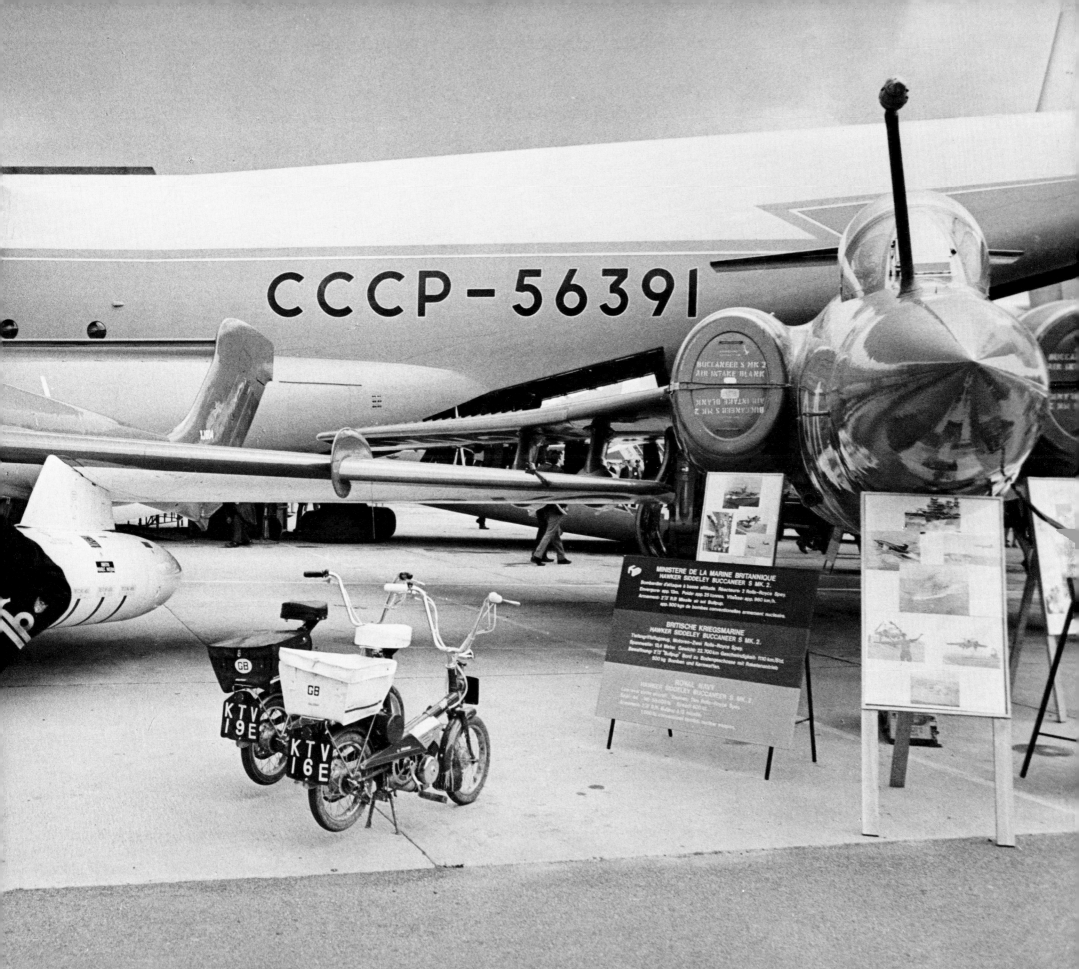

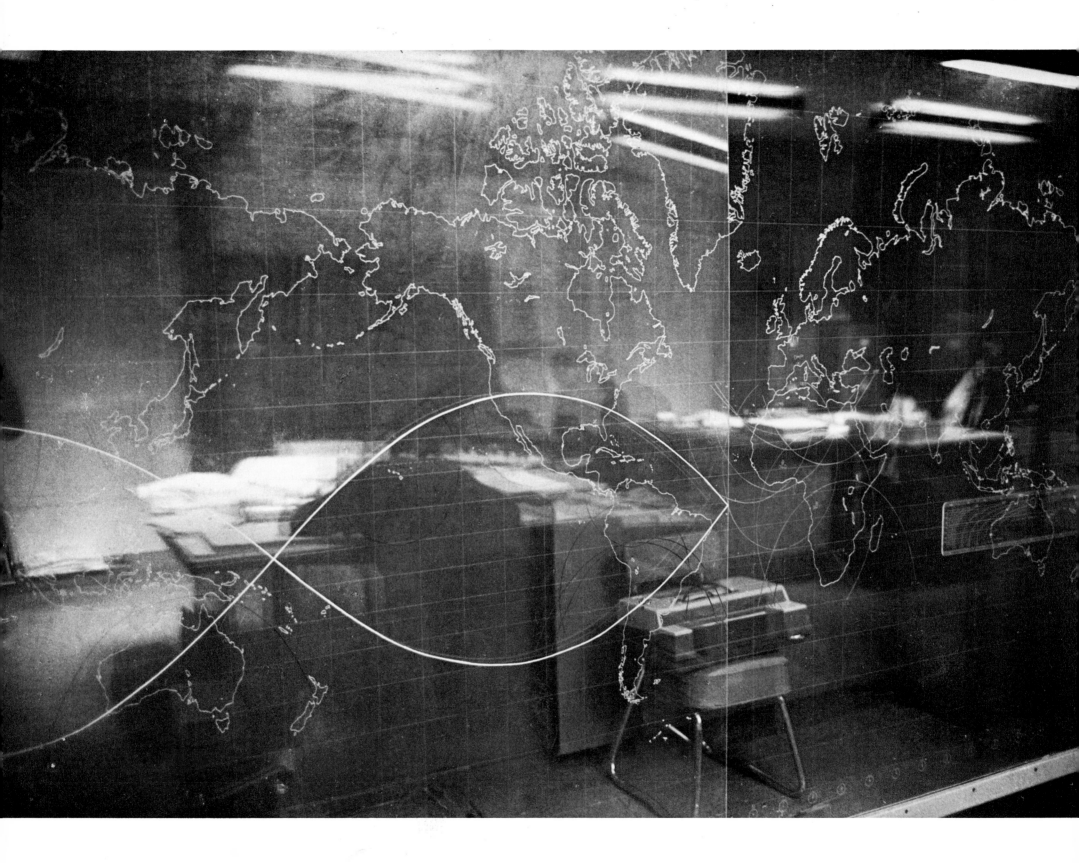

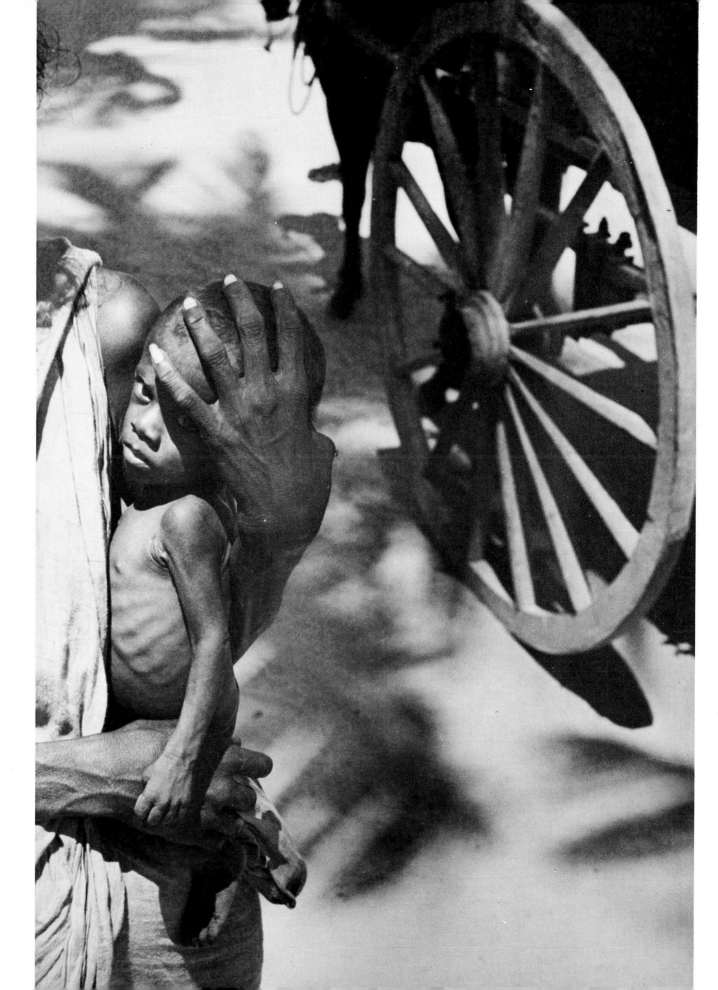

Change is inevitable.
In a progressive country
change is constant.

Benjamin Disraeli

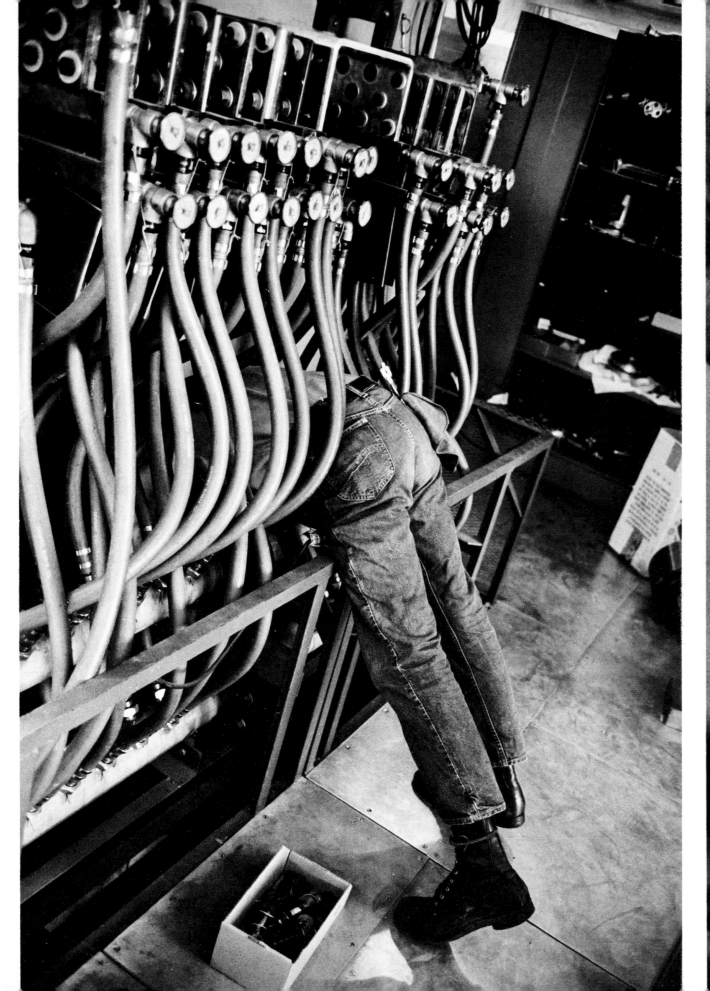

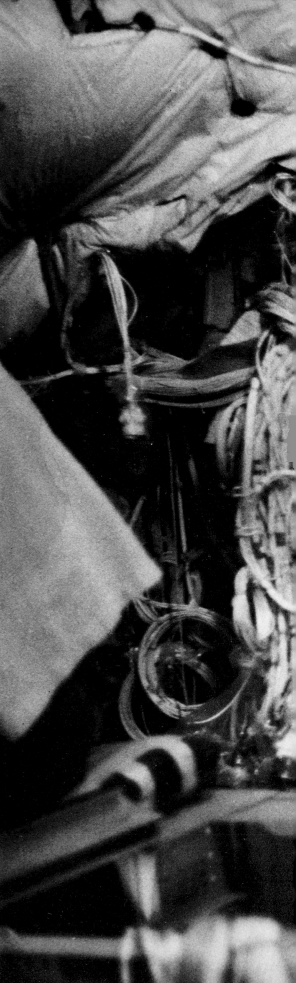

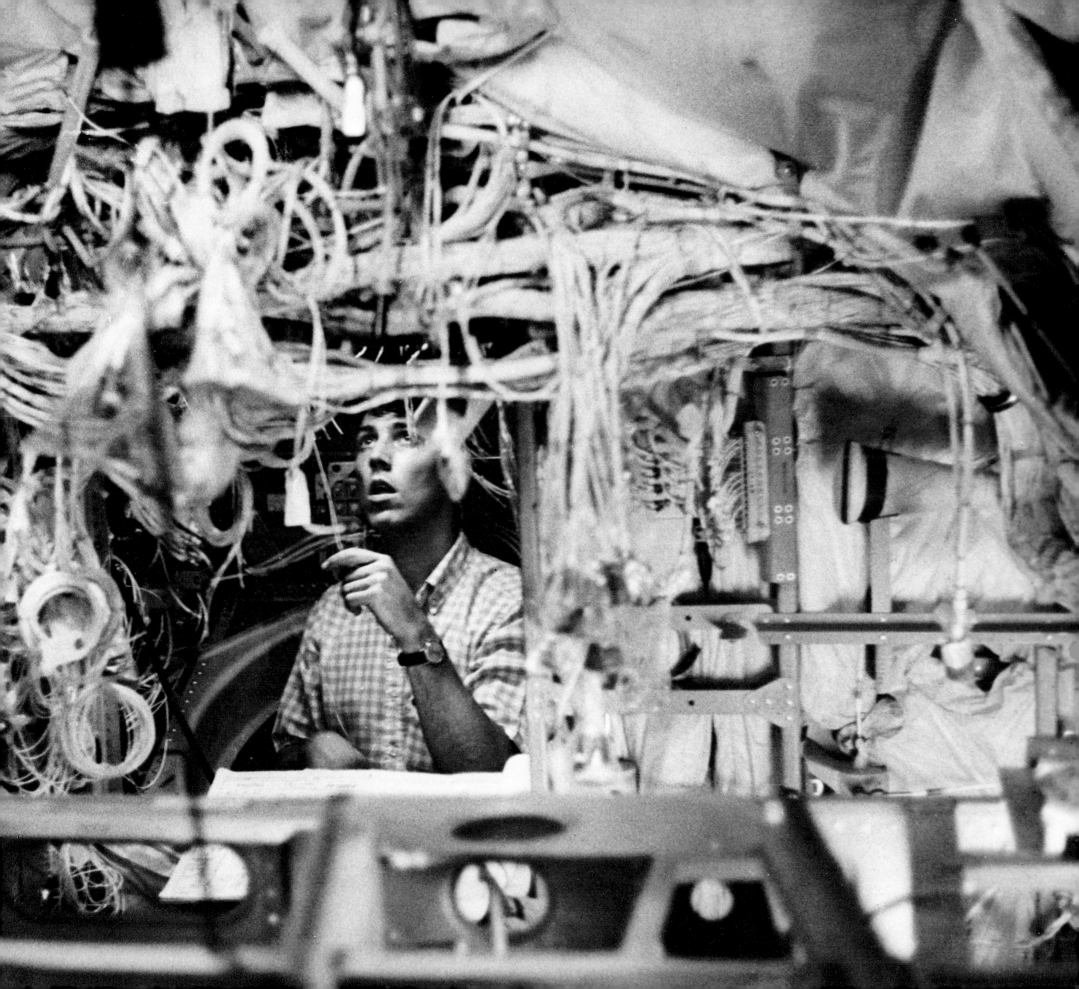

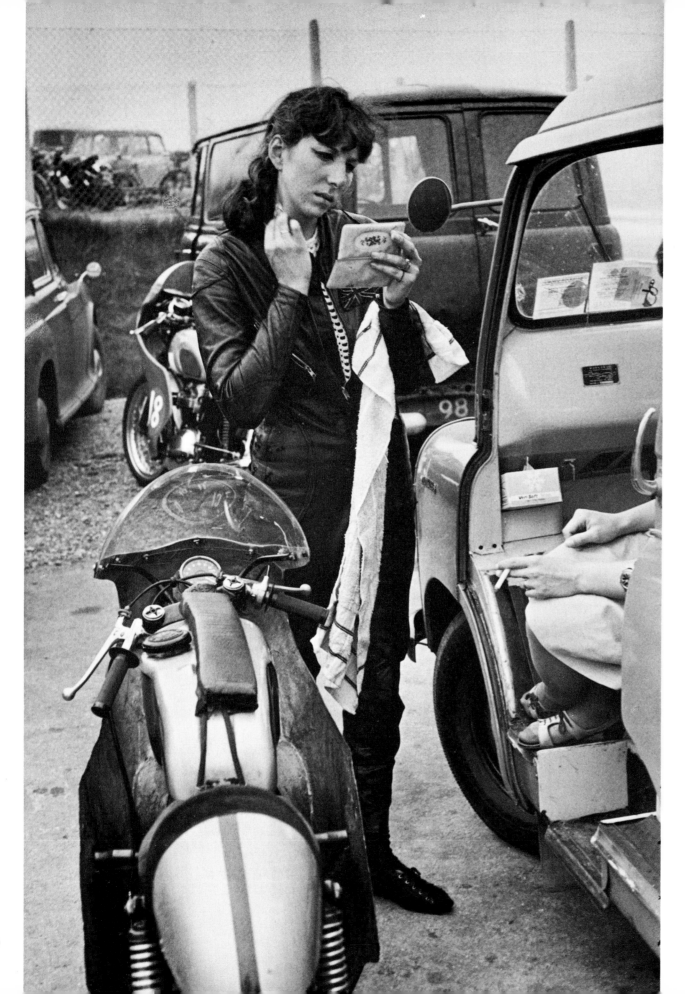

Increased means
and increased leisure are the
two civilizers of man.

Benjamin Disraeli

Any man can now enjoy
with his family the blessings
of hours of pleasure in
God's great open spaces.

Henry Ford

90

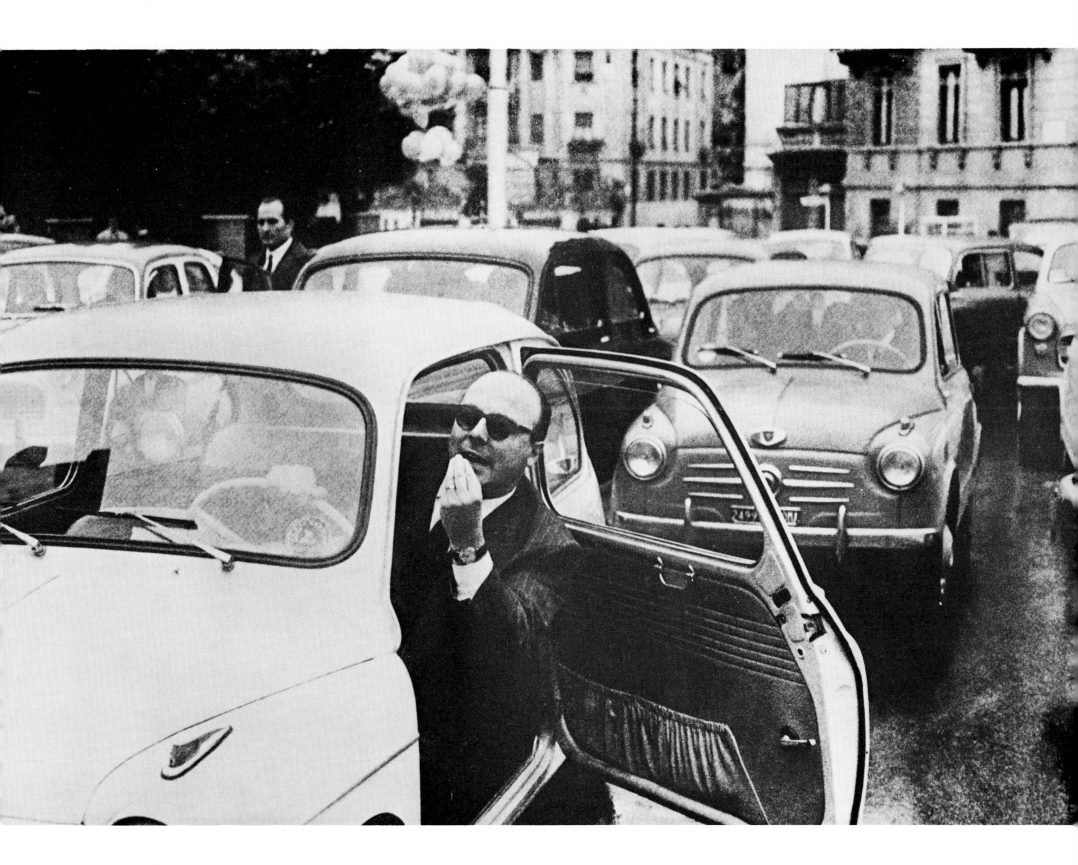

Let's look at the assembly line
in an automobile factory
of the future.
The entire series of operations
will be controlled
by an apparatus similar
to a modern
high-speed computer.

Norbert Wiener

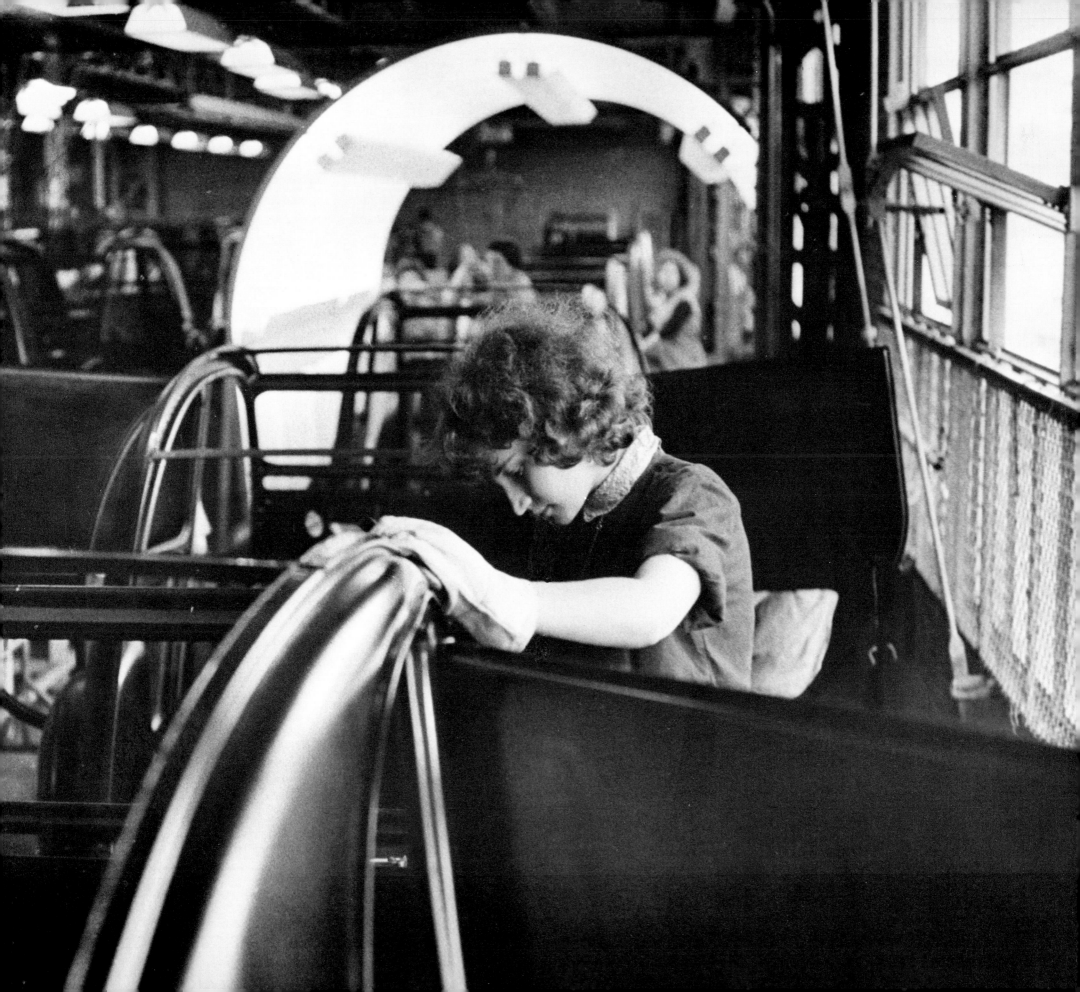

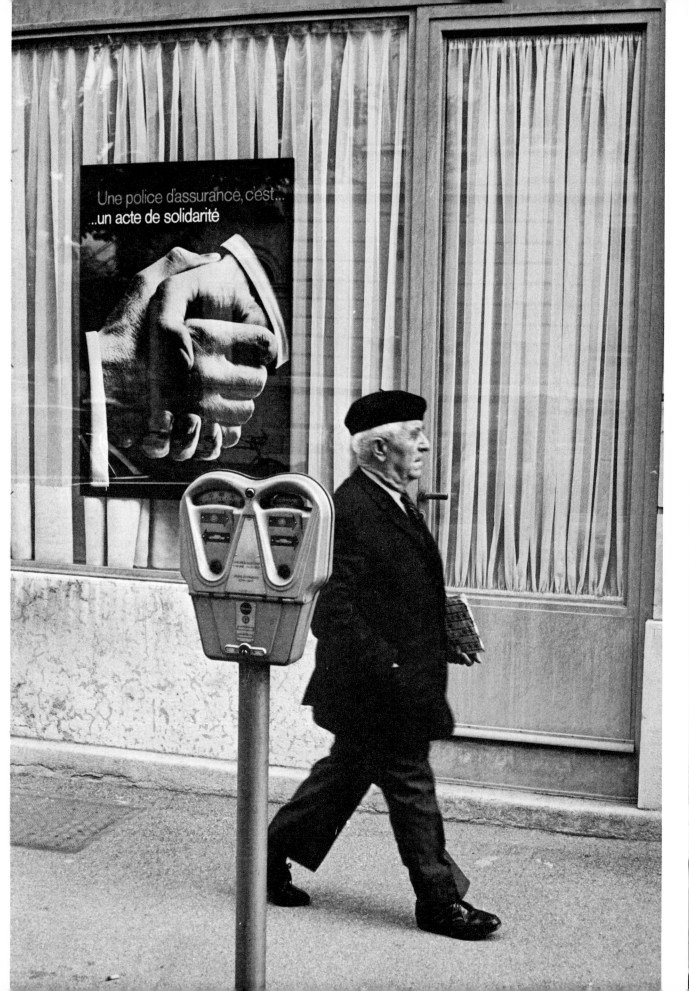

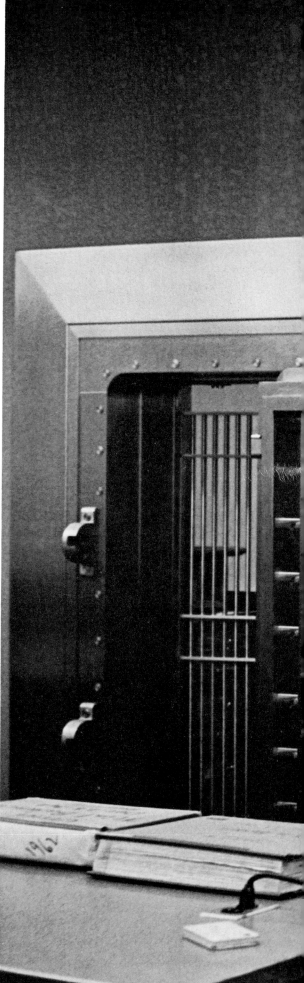

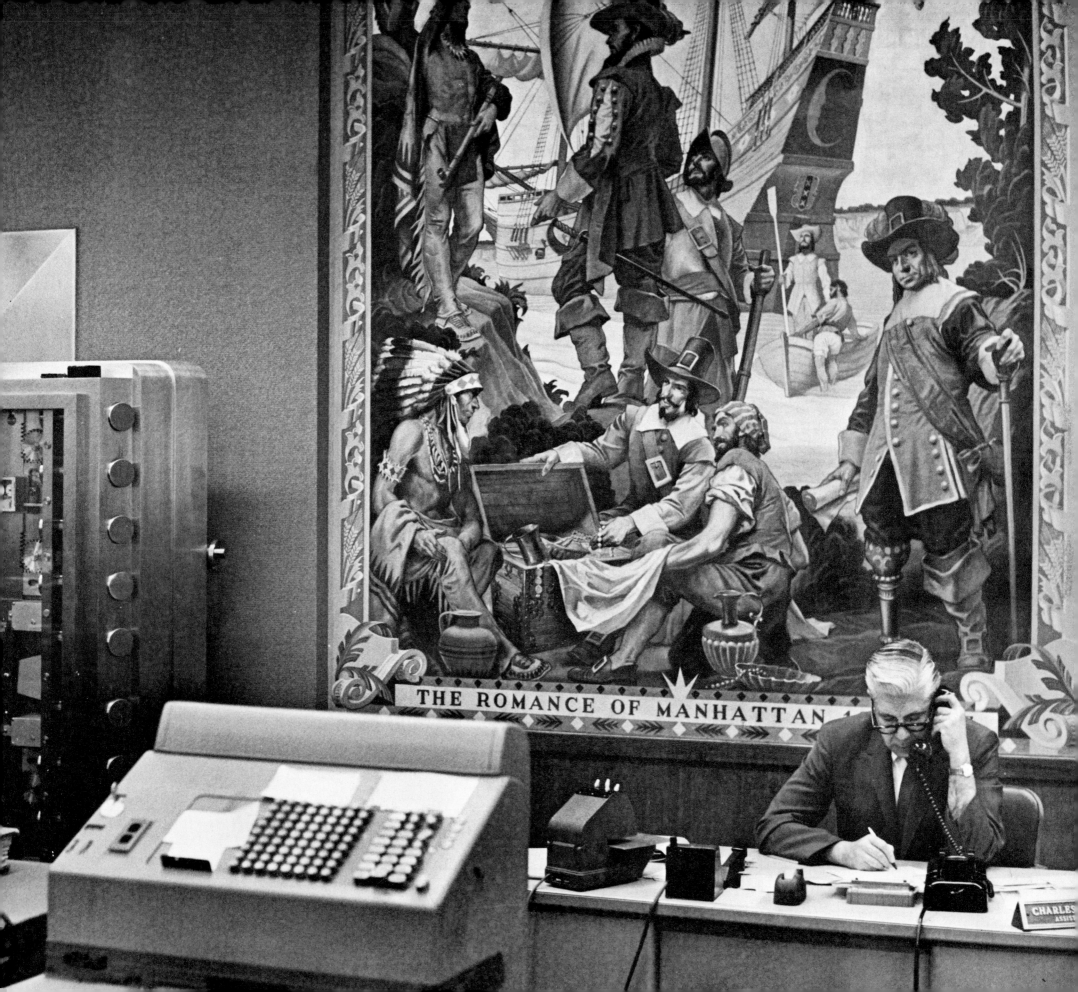

THE ROMANCE OF MANHATTAN

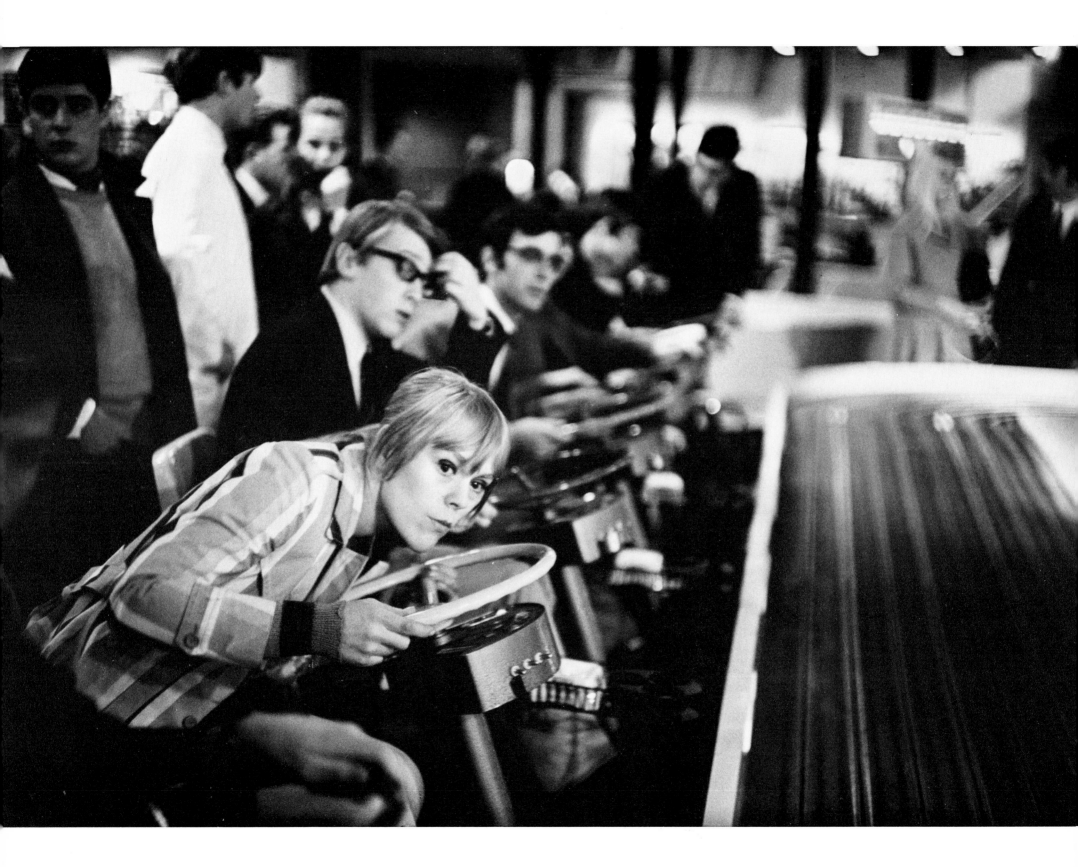

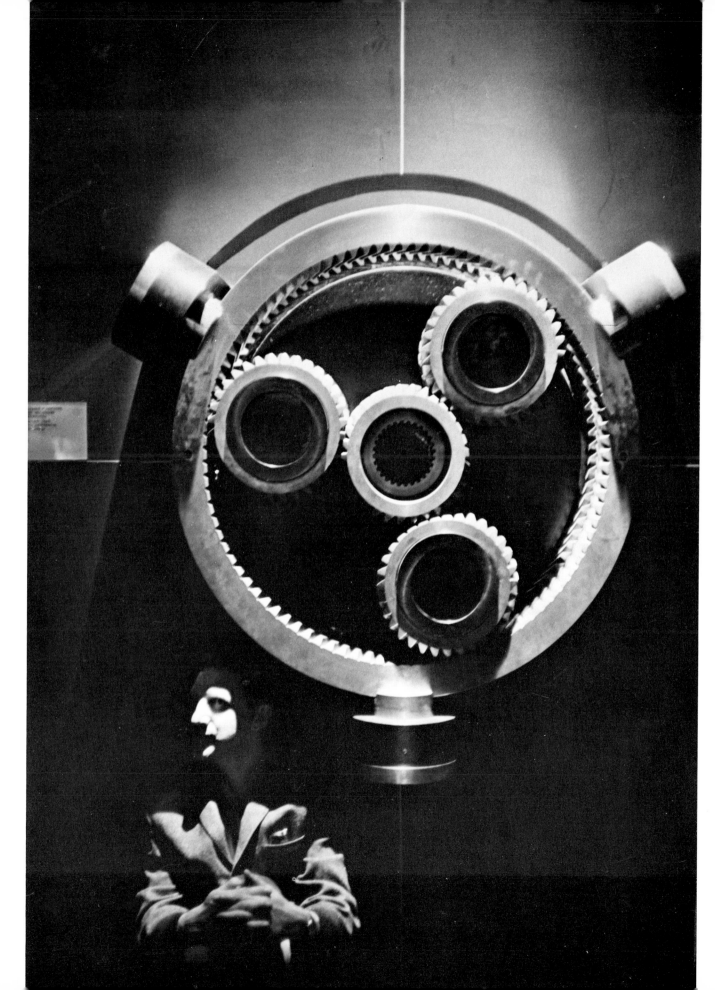

Inventor: a person who
makes an ingenious
arrangement of wheels,
levers and springs,
and believes it civilization.

Ambrose Bierce

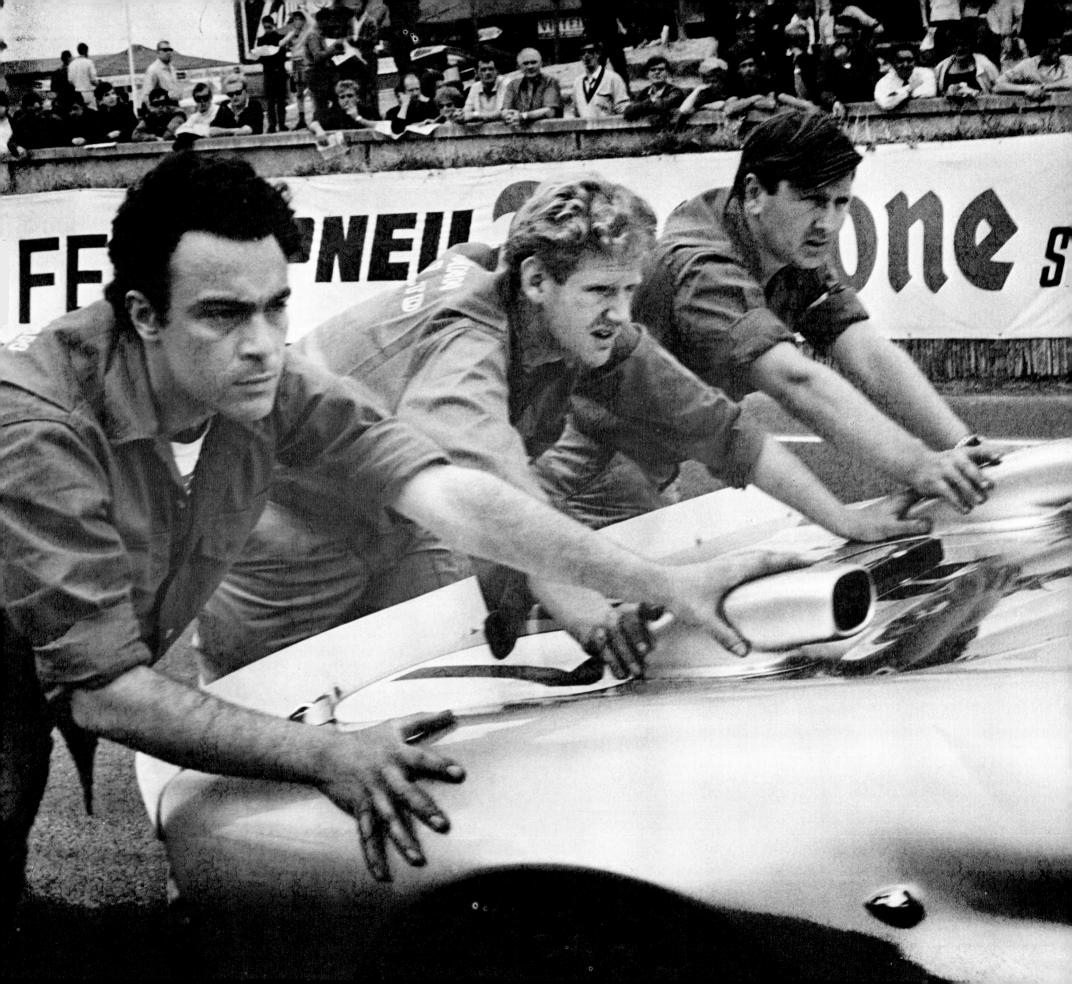

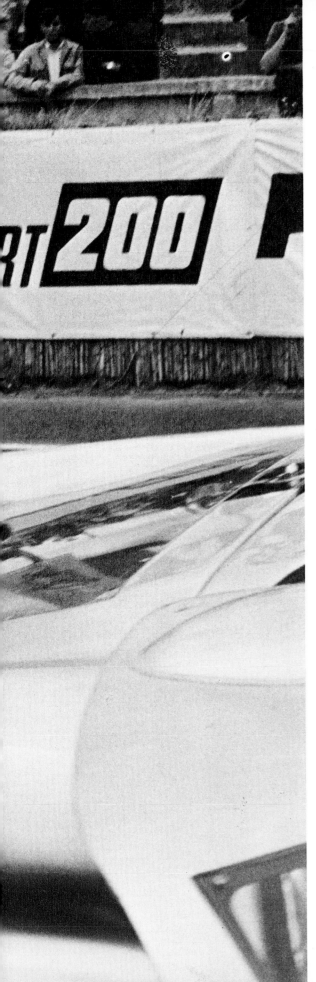

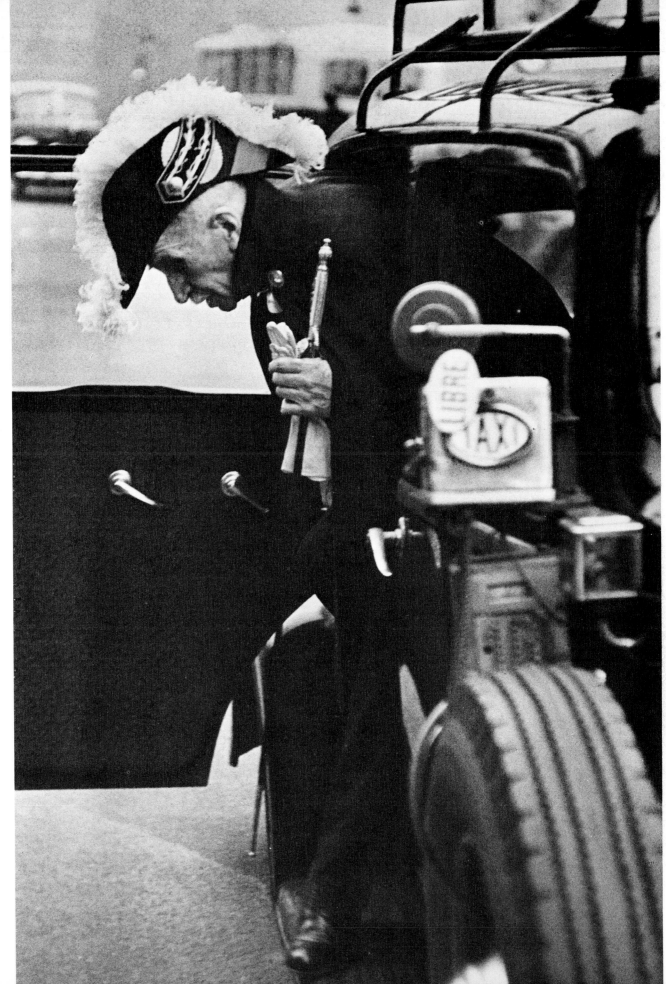

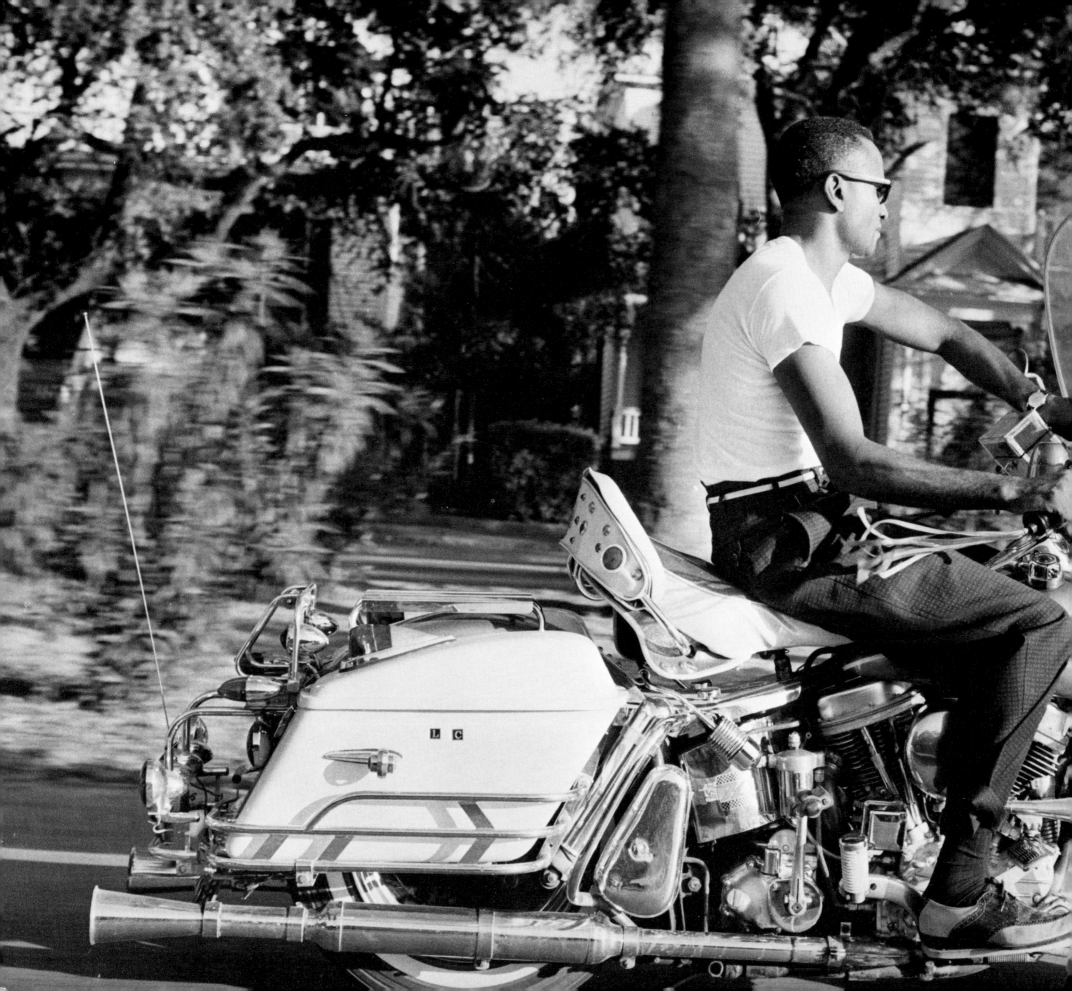

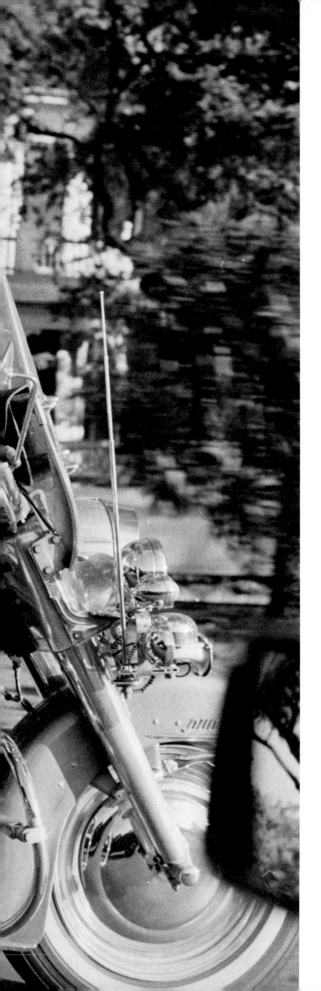

The engine's even vibration,
shaking back through
the fuselage's steel skeleton,
gives life to cockpit
and controls . . . flowing up
the stick to my hand,
it's the pulse beat of the plane.
Let a cylinder miss once,
and I'll feel it as clearly as
though a human heart
had skipped against my thumb.

Charles Lindbergh

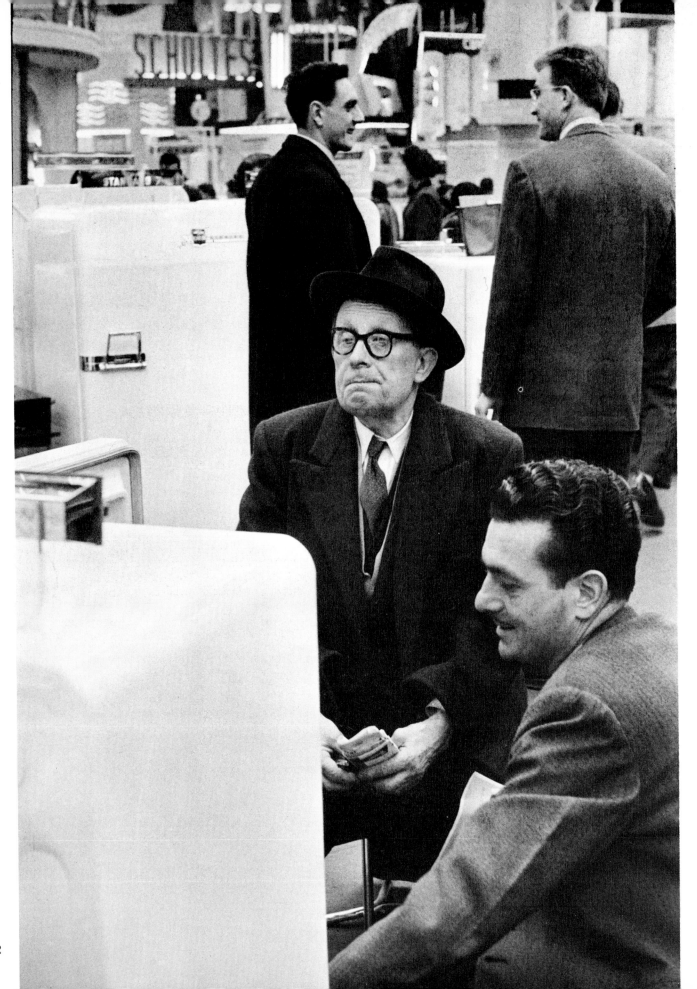

It is not generally realized what
a revolutionary symbol
a refrigerator can be—
to a people deprived of refrigeration.

Sukarno

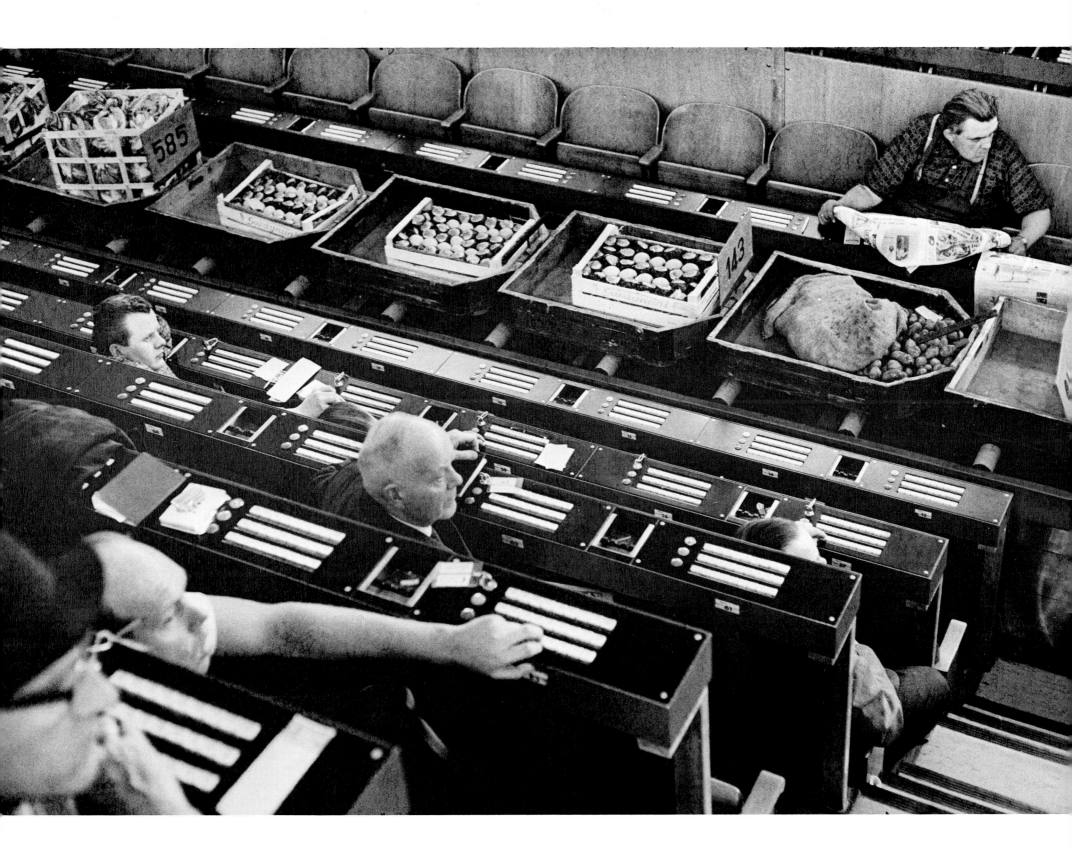

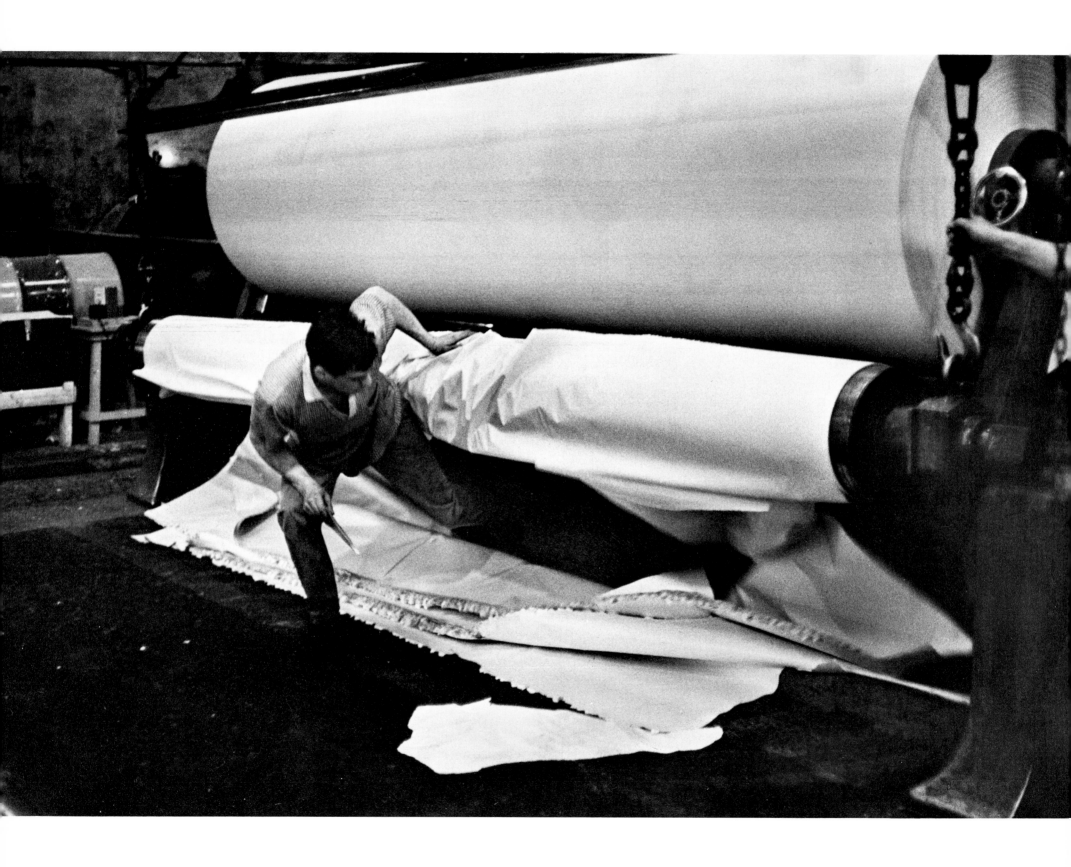

To want a humanism of the
future means the endless toil of
assimilating and mastering
technology: an unlimited challenge
to human effort.

Karl Jaspers

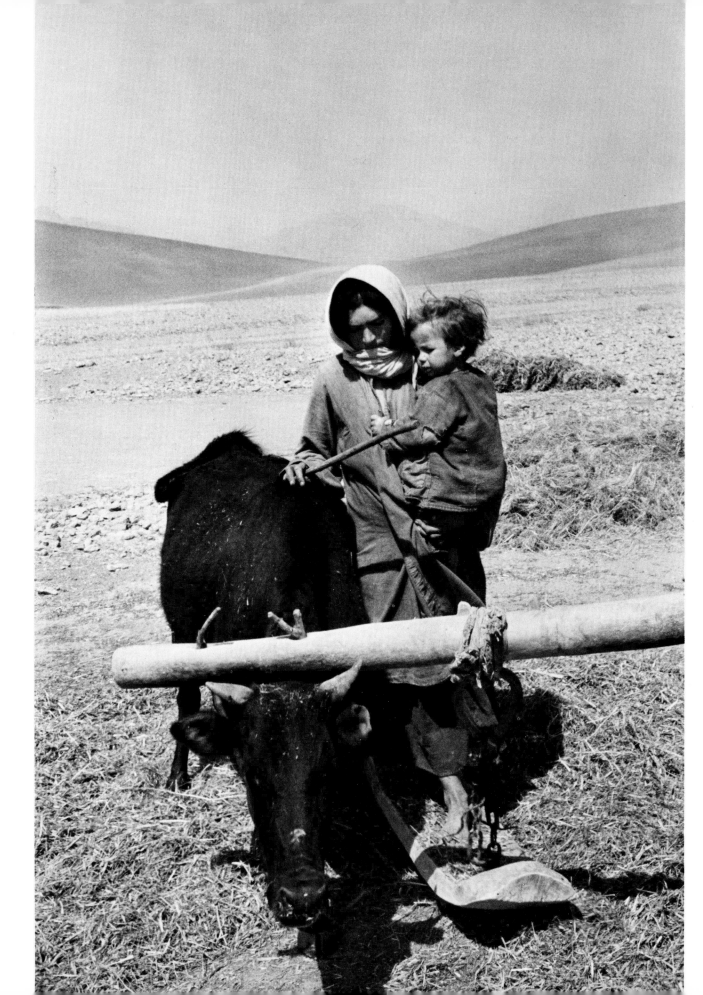

105

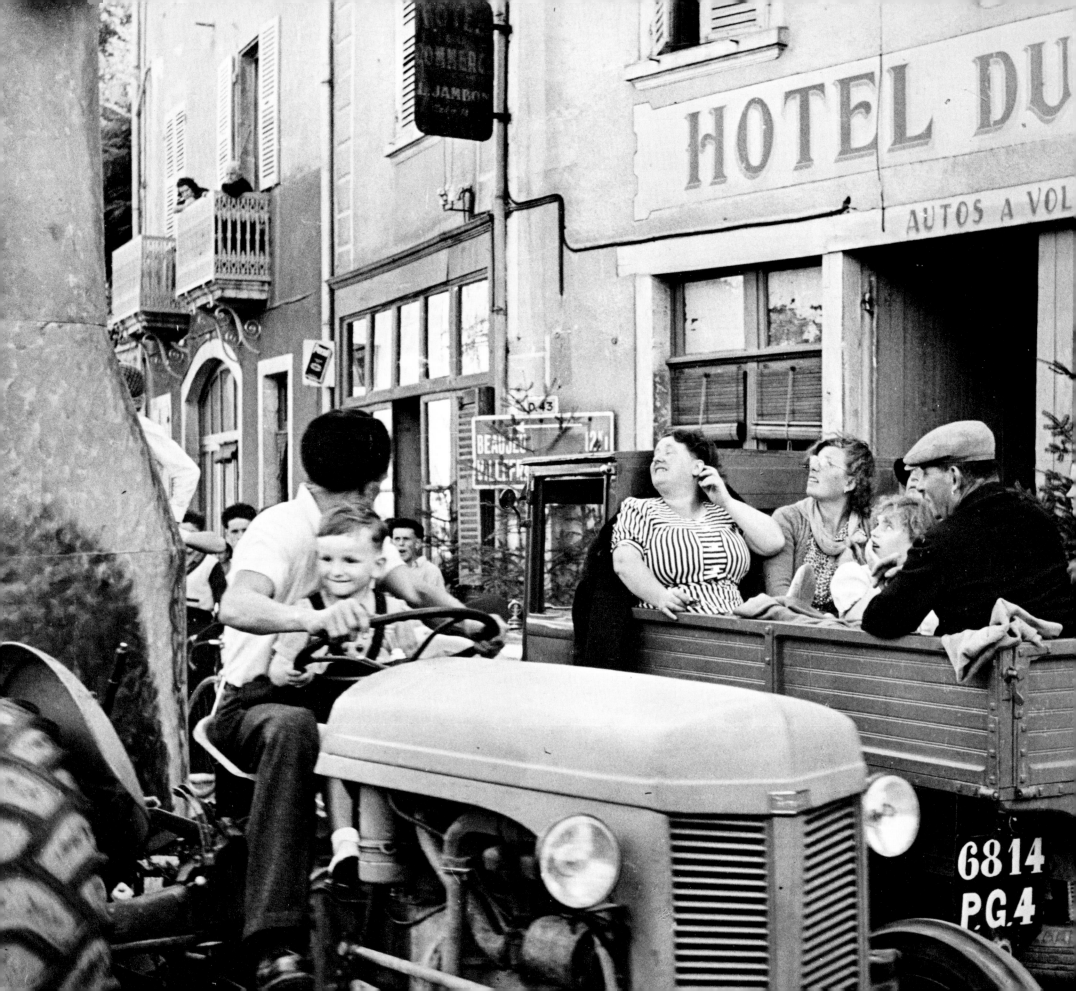

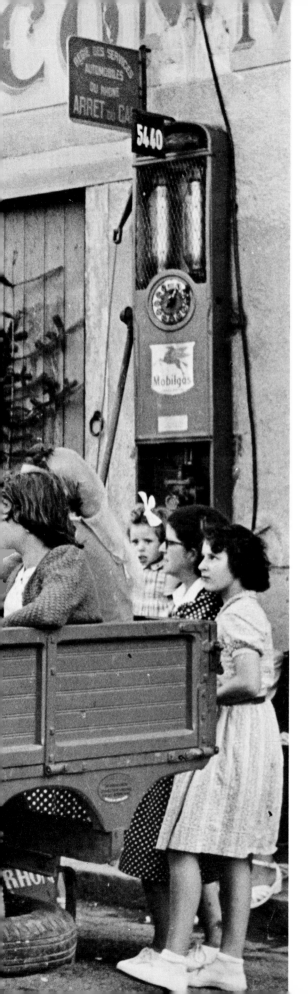
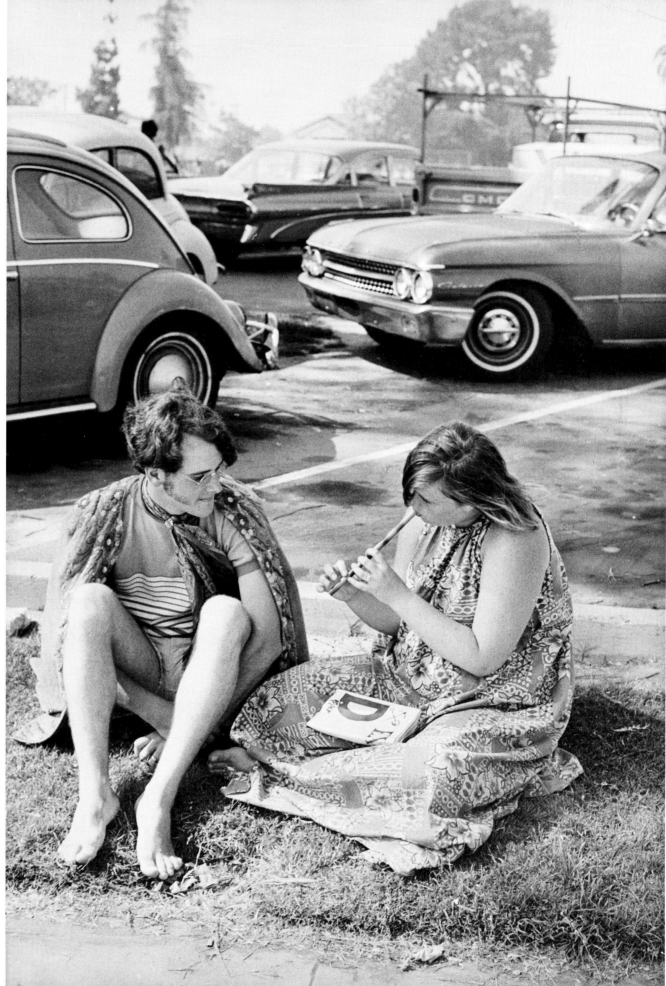

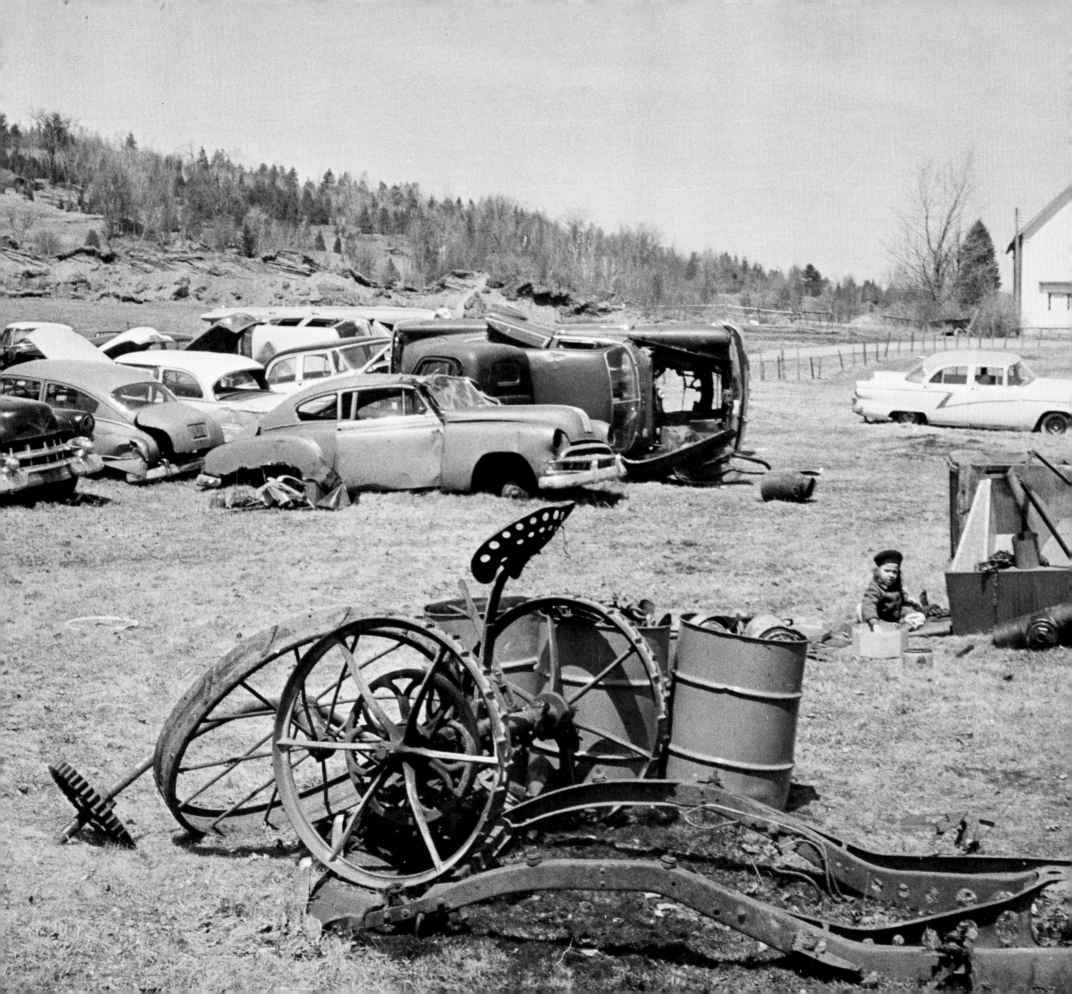

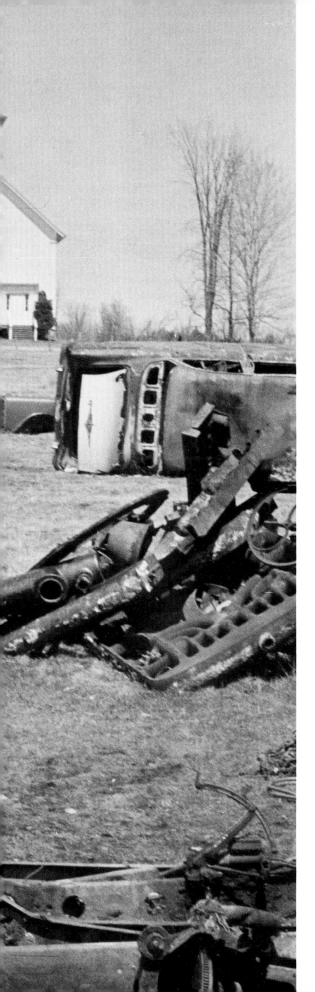

And when I lie
on the green kirkyard
With the mold upon my breast,
Say not that she did well,
or ill,
Only, she did her best.

Dinah Mulock Craik

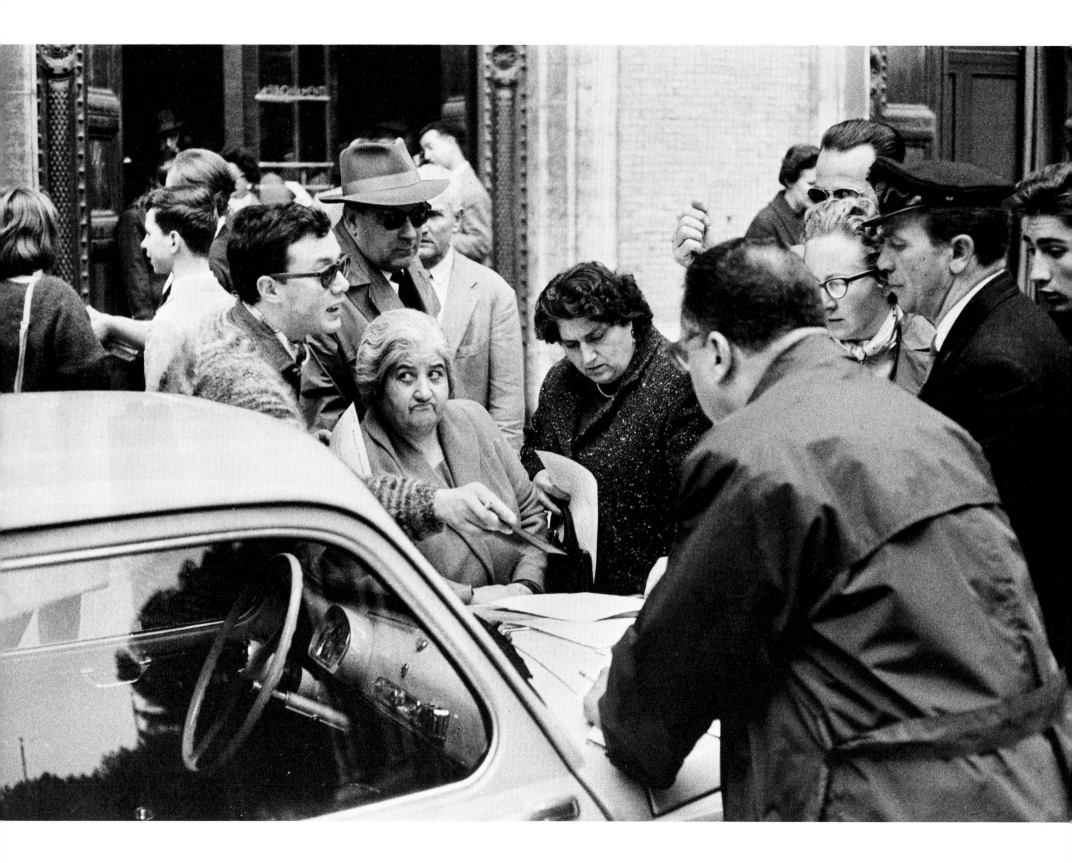

Carriages without horses shall go,
and accidents fill the world with woe.

Mother Shipton 1488-1561

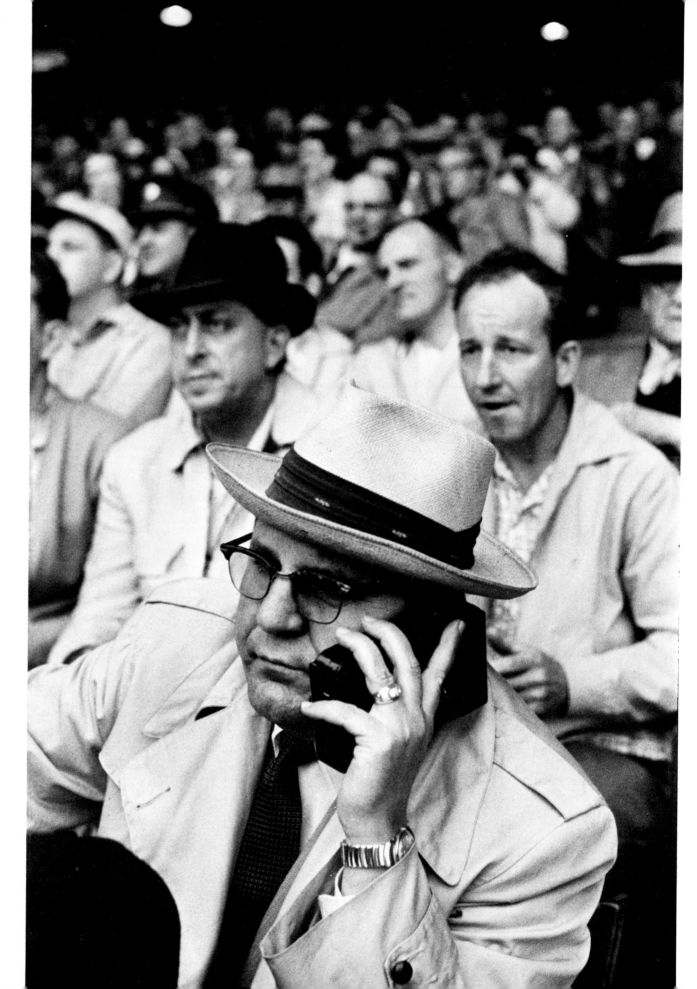

Around the world thoughts shall fly
In the twinkling of an eye.

Mother Shipton 1488-1561

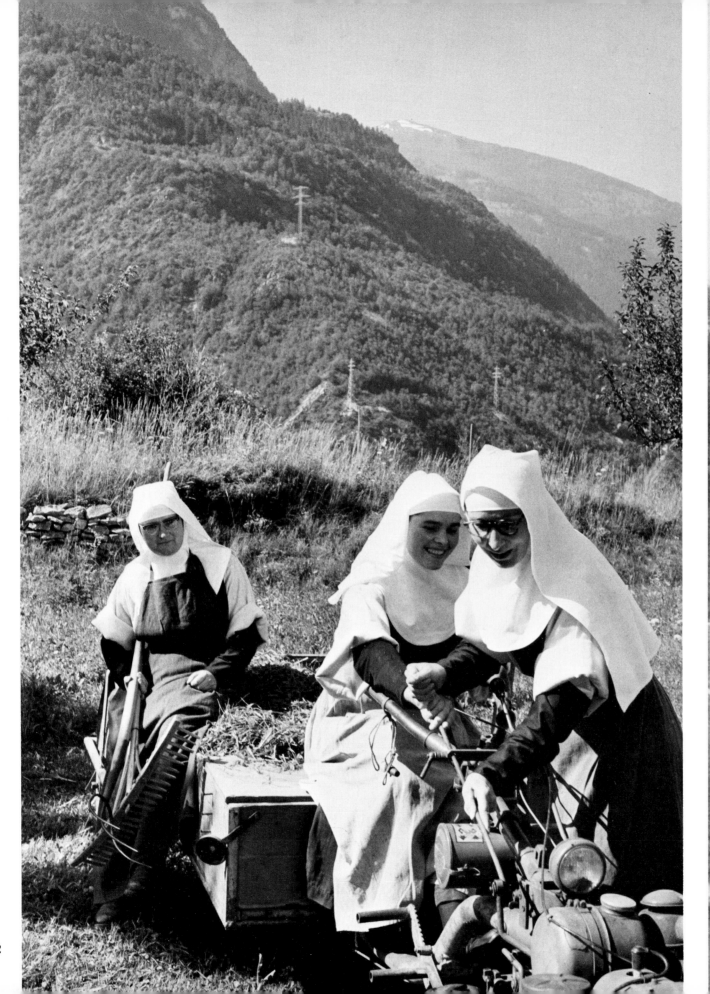

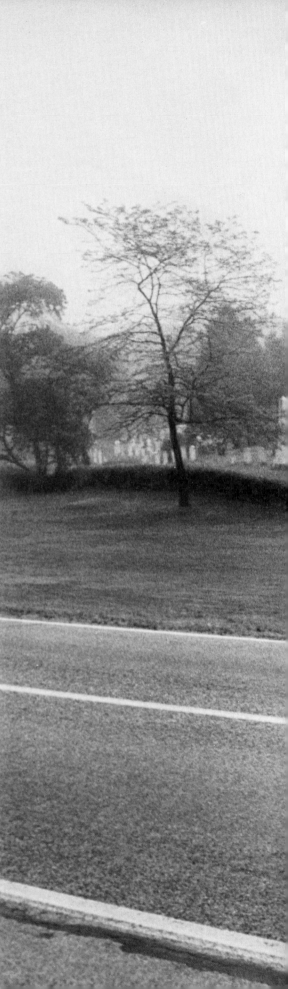

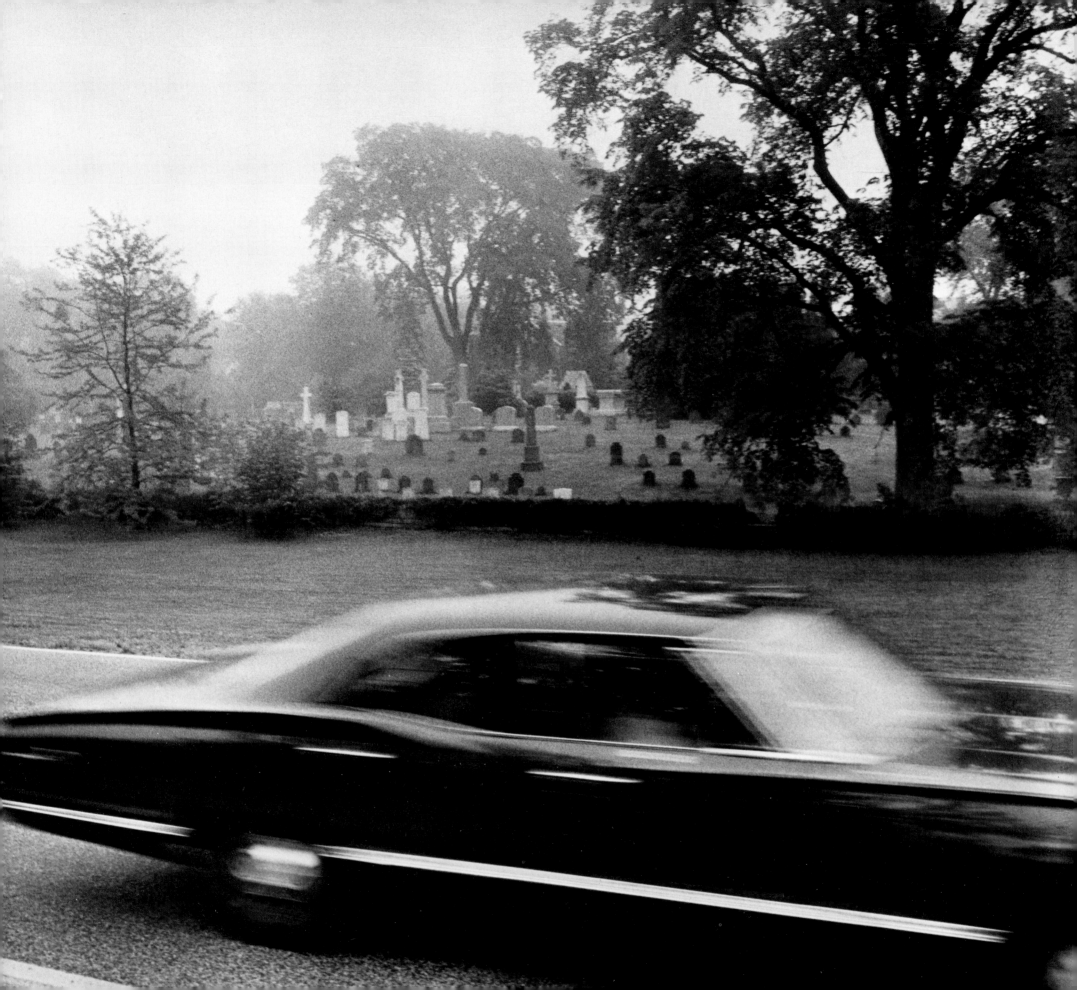

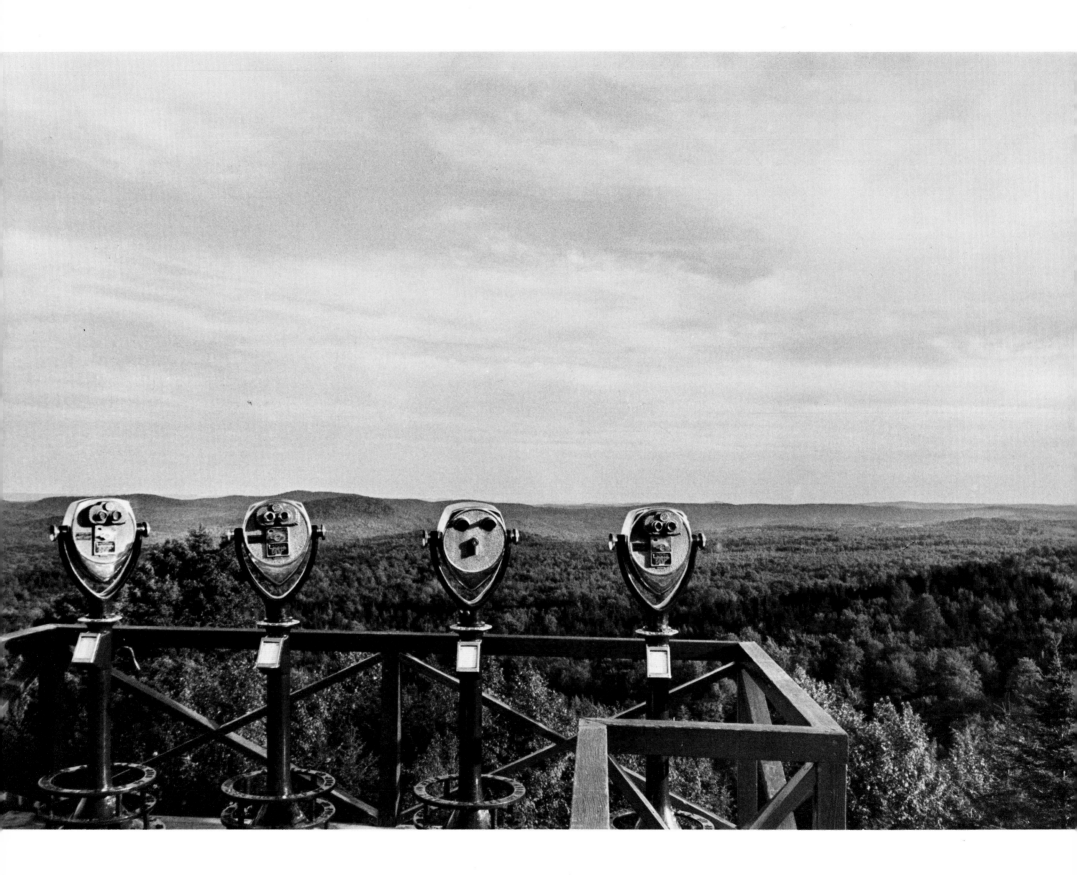

Photographs